LOWESTOFT &
THE SUFFOLK COAST
THROUGH TIME
Michael Rouse

AMBERLEY PUBLISHING

For singer-songwriter John Crowe, one of the most talented and self-effacing persons I have ever worked with. His great-grandfather was William James Crowe, a Lowestoft trawler man whose skipper's certificate, awarded in 1897, is kept today in the archives of the Maritime Museum.

First published 2011

Amberley Publishing
The Hill, Stroud
Gloucestershire GL5 4EP

www.amberleybooks.com

Copyright © Mike Rouse 2011

The right of Mike Rouse to be identified as the
Author of this work has been asserted in accordance
with the Copyrights, Designs and Patents Act 1988.

ISBN 978-1-84868-073-9

British Library Cataloguing in Publication Data.
A catalogue record for this book is available from
the British Library.

Typeset in 9.5pt on 12pt Celeste.
Typesetting by Amberley Publishing.
Printed in the UK.

Introduction

Samuel Morton Peto has interested me for many years. After all, he was the man who brought the railway through Ely in the 1840s and took the line to Norwich and on to Lowestoft, where he was determined to create a new seaside resort to rival Brighton. I had been told that the way the land fell away behind the house that my grandfather built on the edge of Ely was the result of material having been dug out to form the railway embankment not far away. Only a few years ago I found out that the land was once owned by Peto, which confirms it.

As a family we didn't holiday in Lowestoft, but we visited it. Later, in the early 1980s, I made several trips there and I have many happy memories of the Sparrow's Nest and its theatre. Fish and chips at the café followed by a summer show meant I was content. Now, sadly, the theatre is no more. Sparrow's Nest and Belle Vue Park are as delightful as ever, but as with many of the resorts, the live shows seem to be mostly in the nearby holiday camps.

Lowestoft is really a town in two parts: the old town with its fascinating history as a fishing port and then Peto's creation, surrounding the South Pier and the Esplanade, towards Kirkley. There are some splendid Victorian buildings, some impressive regeneration, a very clean seafront and magnificent beaches. But when one older resident said to me, 'The place is dying on its feet,' I worried for the town.

First and foremost, Lowestoft was a fishing port. Visit the wonderful Maritime Museum at the Sparrow's Nest to see for yourself. However, that industry has gone. Some of the major employers in the town, such as Eastern Coachworks, closed in 1886 and the town has suffered some major factory closures since. Today, it needs some serious investment to create jobs. Being the most easterly part of the country is a claim to fame, but it is also a disadvantage in infrastructure terms, unless you are a thriving port like Felixstowe. Now Lowestoft is aspiring to become the centre of the renewable energy industry. The Government has just announced a new coastal communities fund, and if there is any town on the East Anglian coast that deserves a share, it is Lowestoft.

I used to hear much about Pakefield from my old friend David Batley, who as a child found bones from the old churchyard on the sands. So I have gone as far south as Pakefield and Kessingland, as well as exploring the holiday camps at nearby Corton. Finally I have enjoyed visiting Oulton Broad again.

Lowestoft and this part of the Suffolk coast have a proud history and there is much to see and enjoy, as I hope this book will show.

Michael Rouse
July 2011

Acknowledgements

Robert Maltster edited my book *Coastal Resorts of East Anglia* (Terence Dalton, 1982). A well-known writer and historian, he wrote *Lowestoft: A Pictorial History* (Phillimore, 1991), which I have referred to. I have also read and referred to Ian G. Robb's *Lowestoft: Past and Present* (Sutton, 2000; rep. The History Press, 2010) and *A Century of Lowestoft* (Sutton, 1999); and Chris Brooks's *Lowestoft: A Portrait in Old Picture Postcards, Volume 1* (SB Publications, 1991). Of the many fascinating books by Malcolm R. White and Coastal Publications, I have made use of *A Smile from Old Lowestoft* (2005) and *Greetings from Lowestoft* (2001). I managed to buy a copy of *Pakefield in Days Gone By* by Peter Clements (Rushmere, 1991), which offers a loving history of the village in question and its relationship with Lowestoft. Adrian Vaughan's *Samuel Morton Peto: A Victorian Entrepreneur* (Ian Allan Publishing, 2009) is a detailed biography of the great man. Various websites have also been consulted.

I am grateful to the very helpful staff at the Maritime Museum at the Sparrow's Nest (which should be on everyone's list to visit). My thanks also to managers and staff at Waterside Park, Corton Coastal Village, Broadland Sands and Kessingland Beach Holiday Park.

Special thanks to Ian and Ella Crocker at Somerton House on Kirkley Cliff for their hospitality in one of Samuel Morton Peto's original Victorian villas.

To my younger son, Lee, thanks for your companionship; also to my older daughter, Lauren, who accompanied me on my last photographic trip on 29 July 2011 and willingly appears in several photographs. She often grabbed the camera to record memorable scenes of beach huts or of her own feet.

My photographs were taken on four visits in 2011. The weather varied and I am never satisfied, but on each trip I discovered something new and enjoyed myself. Who can ask for more than that?

Finally thanks to Sarah Flight, Joe Pettican, Thom Hutchinson and all at Amberley Publishing – it's a pleasure.

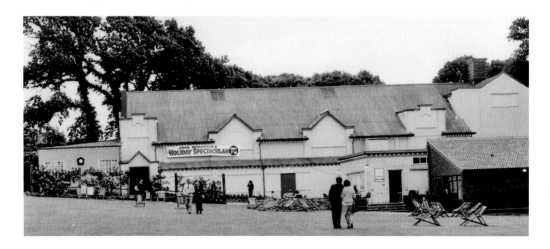

The Sparrow's Nest Theatre in 1980 – so many happy memories.

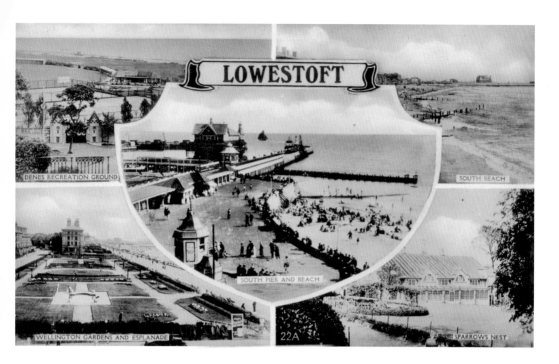

Lowestoft

An ancient settlement, a port town and the most easterly point in the United Kingdom, Lowestoft is a seaside resort on the Sunrise Coast and boasts some of the best sandy beaches in the country. It is the birthplace of Benjamin Britten and – a personal favourite – the illustrator Michael Foreman, whose book *War Boy* is an account of childhood in Pakefield. Once famous for its porcelain, Lowestoft is hoping to revive its fortunes as a new centre for the renewable energy industry.

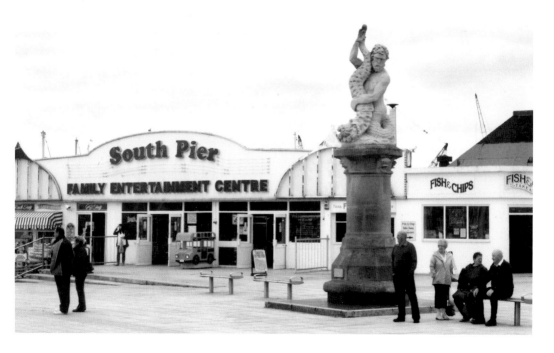

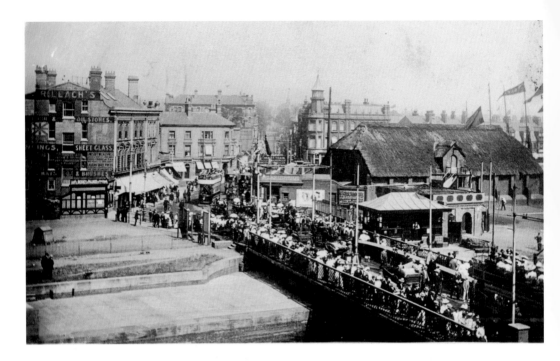

The Bridge

The Norwich & Lowestoft Navigation Company cut the first channel between Lake Lothing and the North Sea in 1830 and constructed a cast-iron bridge that opened in the centre – although Old Lowestoft did not stretch beyond the bridge. In 1897 the bridge was replaced with a swing bridge constructed by the Great Eastern Railway Company. Between 1901 and 1931, the town had 4 miles of tramway from North Lowestoft through to the Tramway Hotel at Pakefield; some of the trams can be seen above. The Millennium sculpture by Dominic J. Marshall is dedicated to all Lowestoft lifeboatmen past, present and future.

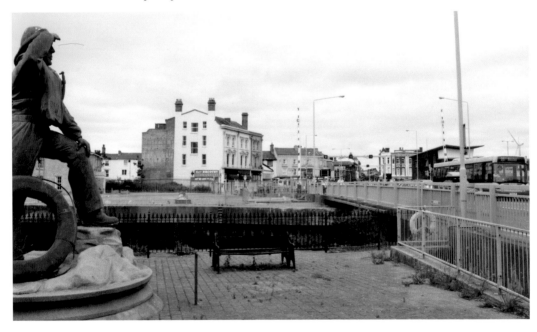

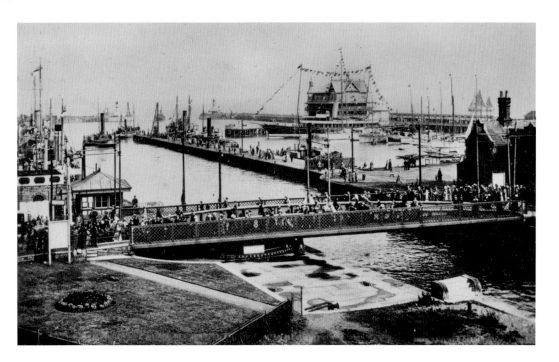

The Bridge and Yacht Basin

The great Victorian engineer and entrepreneur Sir Samuel Morton Peto shaped Lowestoft's destiny. Described as the 'father of modern Lowestoft', he developed the town south of the bridge. In 1844 Peto bought Somerleyton Hall and rebuilt the house. He built the outer harbour at Lowestoft to stop the inner harbour silting up and to enable navigation from Norwich through to the sea. In 1969 the swing bridge failed and after three years of a temporary structure the present bridge was opened in 1972. Unlike its predecessor it is a bascule bridge.

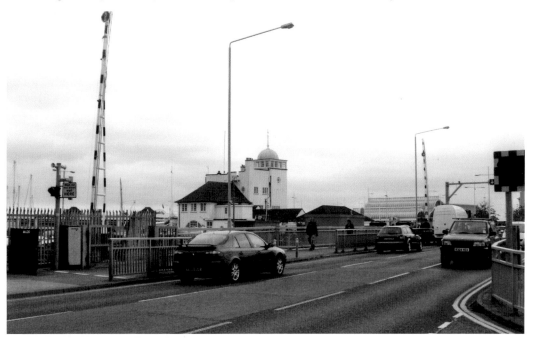

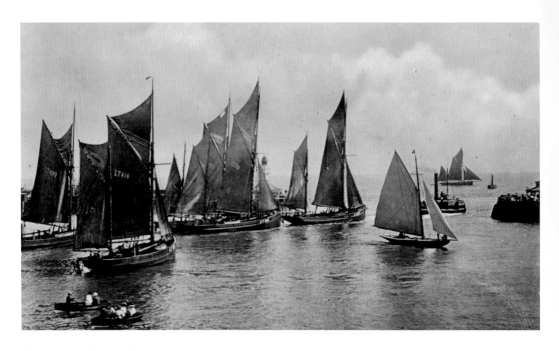

The Fishing Fleet Pulling out to Sea

Fishing has been a major industry for Lowestoft from its beginnings, with the fishermen working from the beach at the foot of the cliffs of the old town. In 1862 the Great Eastern Railway Company became owners of the harbour and the trawl basin. Such was the success of the industry that the Waveney Dock was opened by Lord Waveney in 1883 and with the Hamilton Dock – opened by Lord Claud Hamilton, chairman of the Great Eastern Railway, early in the twentieth century – Lowestoft was at the forefront of fishing ports.

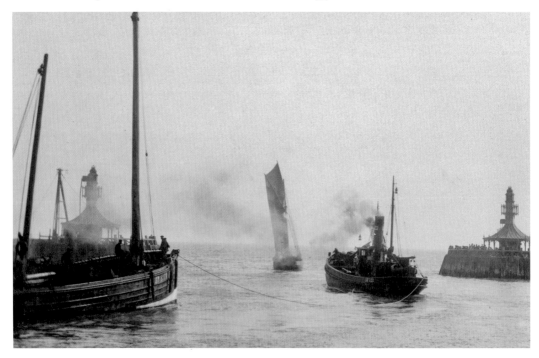

Herring Port, Lowestoft

During the autumn in the first half of the twentieth century, the Scottish drifter fleets followed the fish down the east coast. The Scottish fisher girls followed them by train for the herring season. Tough and skilful, they were often called 'the Scotch girls' and they were a popular feature around the town for a couple or months or so. In the years immediately before the First World War as many as a thousand drifters were working during the herring season. Vast quantities of herring were caught, landed and gutted. Dried herrings were sent for export; bloaters and kippers were cured.

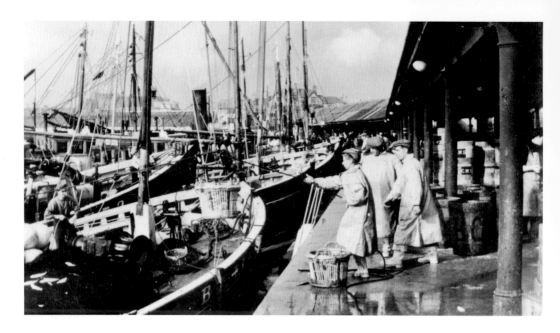

Landing Herrings

It seems incredible that in the second half of the twentieth century the fishing industry declined so rapidly. Supporting the North Sea Gas fields helped the economy for a while and now Associated British Ports have plans to make the harbour the centre for the Greater Gabbard Offshore wind farm, the largest in the world. The Waveney Dock was inaccessible but in 2008 by using floating pontoons some forty-seven new berths were created in the Hamilton Dock, seen below.

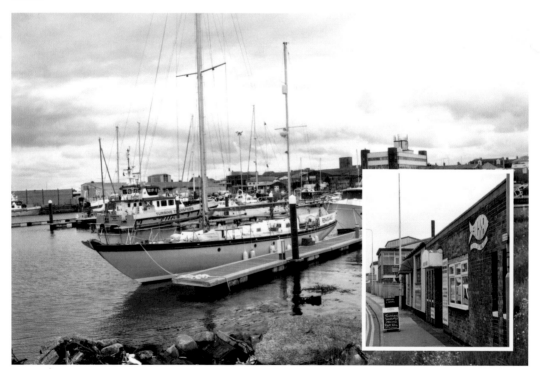

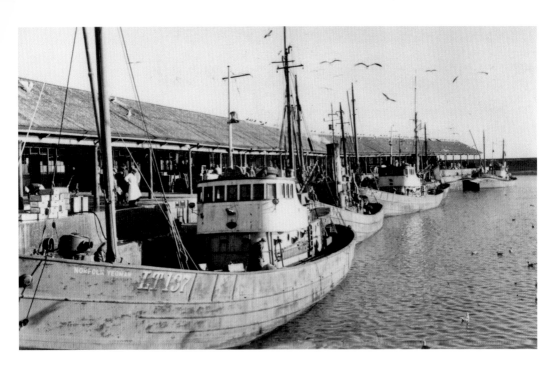

Lowestoft Drifters, Waveney Dock

In the years after the Second World War the number of drifters fell from around forty to around six. The Norfolk Yeoman LT 137, skippered by Ritson Sims, won the Madam Prenier Award for 186½ crans of herrings landed in 1963. At that time there were some six English drifters working and about fifty-three Scottish drifters. The Norfolk Yeoman was sold in 1968 and left Lowestoft. Today the *Mincarlo* – a sidewinder trawler built at the Brooke Marine yard in 1961 and restored by charitable trust – is moored in the harbour as a reminder of Lowestoft's fishing heritage.

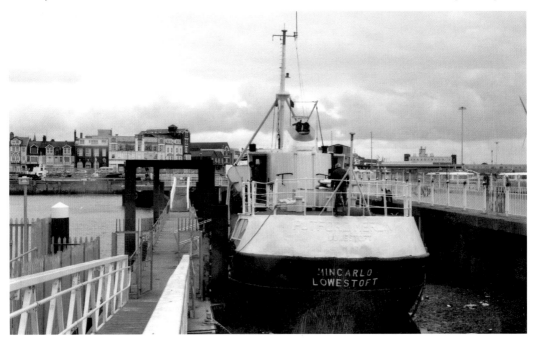

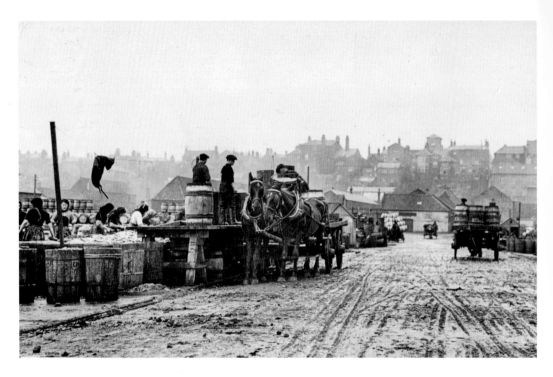

Unloading Herring for Gutting

In the 1920s and 1930s the Lowestoft drifter numbers exceeded a thousand. The economy of the town was based around fishing, with businesses coopering the barrels, making the ice to pack the fish, clothing the fishermen and victualling the trawlers and drifters. Then, of course, there were the merchants who arranged for the fish to find its way into shops and onto the nation's tables.

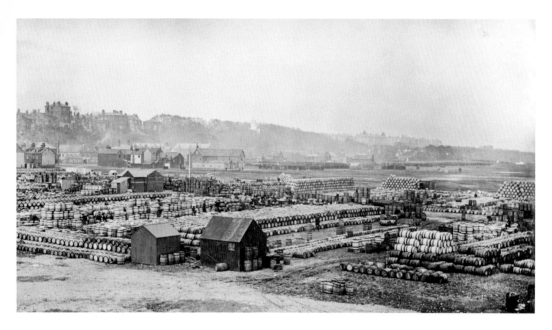

The Pickling Plots

The pickling plots stretched along from the docks. There was a huge export market for pickled herrings and the Scottish girls were experts at their work. The 1960s saw much of this area cleared of the buildings associated with the fishing community and the creation of industrial areas and new roads. The new OrbisEnergy centre and the 126-metre-high wind turbine, known locally as Gulliver, dominate the skyline. Where the sea pounds against heavy rocks piled before the promenade is as far east in the UK as you can go.

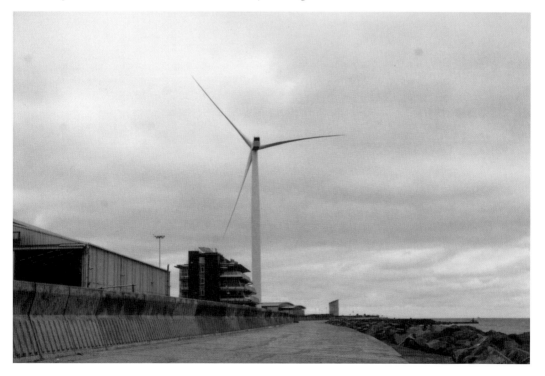

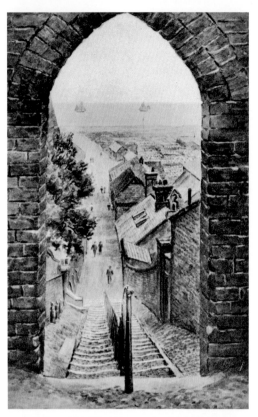

Mariners Score

A number of narrow alleys known as 'scores' link the High Street with the north beach area below. Mariners Score has a flight of steps that can only be used by pedestrians, while some of the scores could have been used by carts. The Birds Eye food factory built on the old pickling plots can just be seen through the greenery. From 1627 there was a timber tower 'low light' at the foot of the score. In 1866 this was an iron structure; ships had to line up the low light and the high light for safe passage. It was dismantled in 1925.

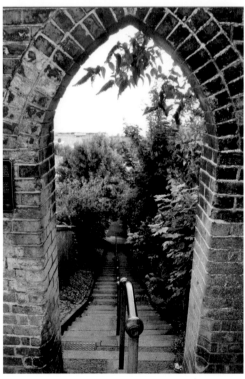

Lighthouse Cottages

T. West Carnie, in his *In Quaint East Anglia* (1899), writes of the prettiness of 'the old town with its red roofs and narrow lanes leading down the cliff to the fishermen's quarters'. These old cottages stood at the foot of Lighthouse Score, which took its name from the High Lighthouse. The cottages were demolished for new housing in 1938. The old posts and rails, where the fishermen dried their nets, are still in place, as well some of anchors salvaged by the Old Company – formed in 1801 for the fishermen to carry out rescue and salvage work.

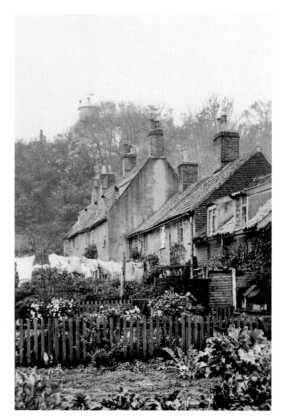

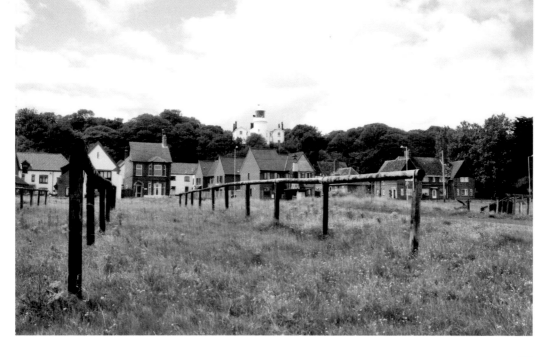

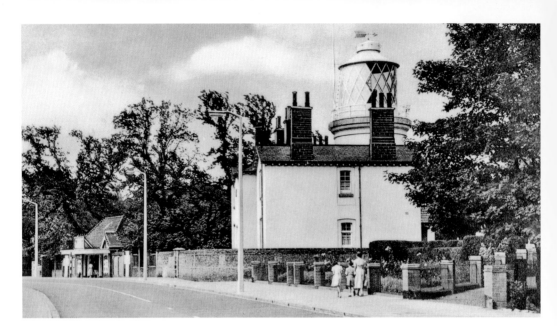

The High Lighthouse

Lowestoft's High Lighthouse stands on the cliffs at the north end of the town. The first light was established there by Samuel Pepys in 1676. This lighthouse dates from 1874 and has a range of 23 nautical miles. The fishermen who lived in the cottages below the cliffs relied on it and the Low Light to navigate the channels while bringing home their catch. The building and its setting have changed little over the years.

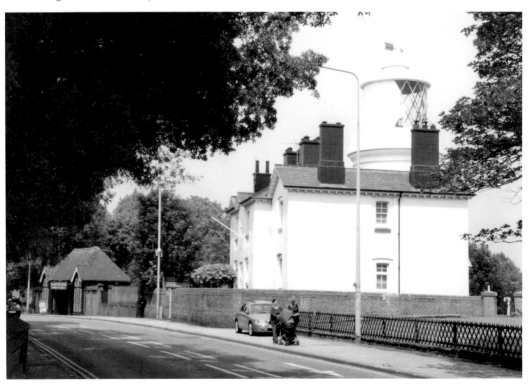

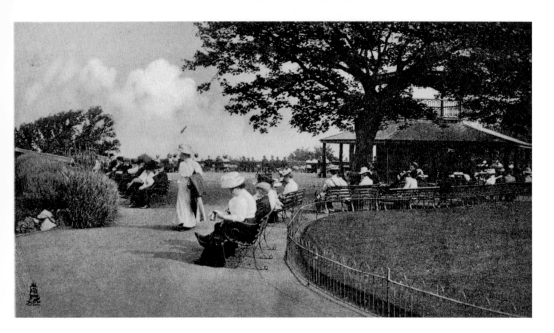

Belle Vue Park

Close to the High Lighthouse are the entrances to the Sparrow's Nest Gardens and Belle Vue Park. Belle Vue is a delightful small park at one of the highest points of northern Lowestoft. Planned early in the nineteenth century, it was eventually built in 1874, with a refreshment pavilion and bandstand. Today on the site of the old bandstand is a fine memorial to the 2,385 members of the Royal Naval Patrol Service who lost their lives at sea during the Second World War. The nearby cannons are a reminder that this was the site of the North Battery in the late eighteenth century.

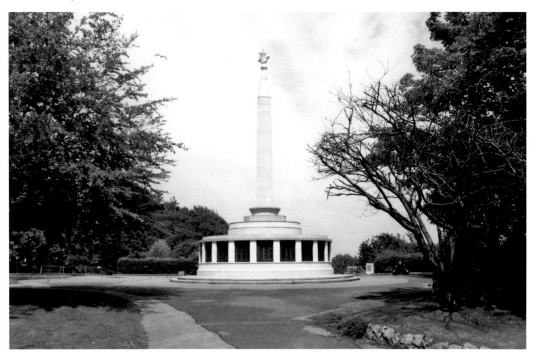

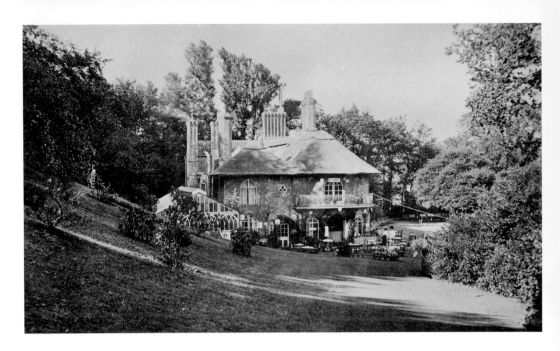

Sparrow's Nest

Next to Belle Vue Park and taking visitors from the cliff top to the bottom, the popular gardens cover nearly 7 acres. They take their name from Robert Sparrow, who was the nineteenth-century owner of the park and had a summer residence there. The Lowestoft Corporation bought the park in 1897 and in the summer months visitors were entertained by concerts in the tented pavilion. The old house changed a lot over the years and was eventually replaced by the existing restaurant.

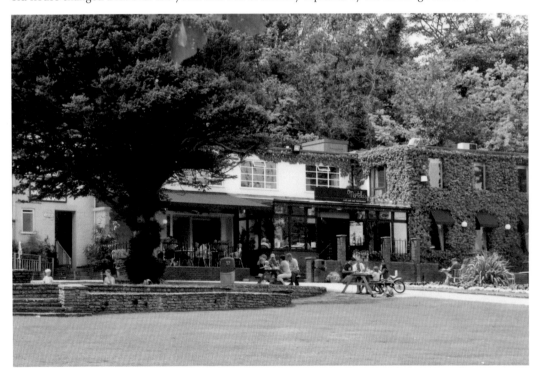

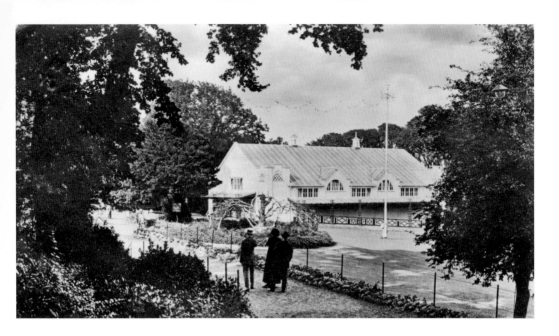

Sparrow's Nest Theatre

The park was such a popular venue for entertainment that in 1913 the pavilion theatre was built. Residents and visitors enjoyed the summer seasons of shows and in 1933 it was improved. In 1939 entertainers Elsie and Doris Waters were enjoying the last of a very successful summer season when war was declared and the park was taken over by the military. The theatre became HMS *Europa*, a base for the Royal Naval Patrol Service. After the war, shows resumed until the Marina Theatre was refurbished in the town; the much-loved little theatre was demolished in 1991.

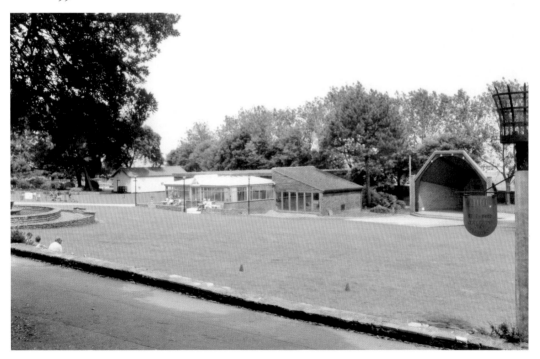

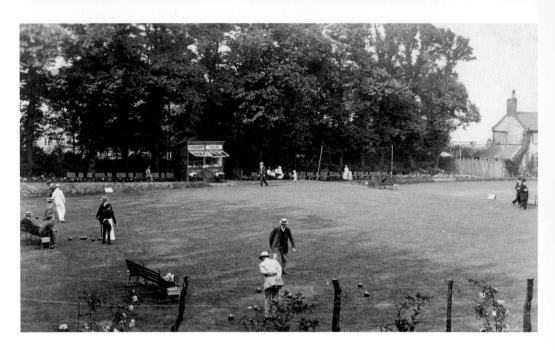

Sparrow's Nest Bowling Greens
The shell bandstand was rebuilt in 1994 as a memorial to all Royal Navy personnel who served in the Second World War. The Royal Naval Patrol Service – some 70,000 men and 6,000 boats, including poorly armed trawlers, whalers and drifters, yachts and tugs – patrolled the British coast, particularly clearing it of mines. In the little cottage on the Whapload Road is the wonderful Lowestoft Maritime Museum, established in 1968 and extended in 1978, 1980 and 2010. It is open from April to October.

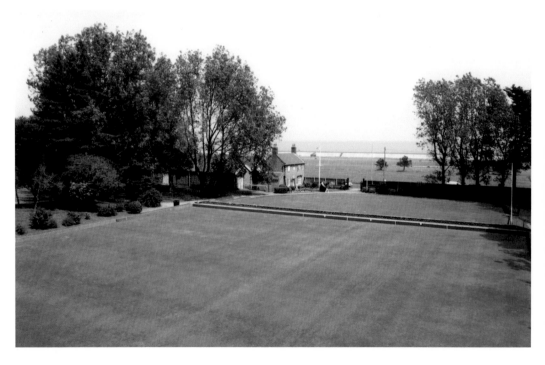

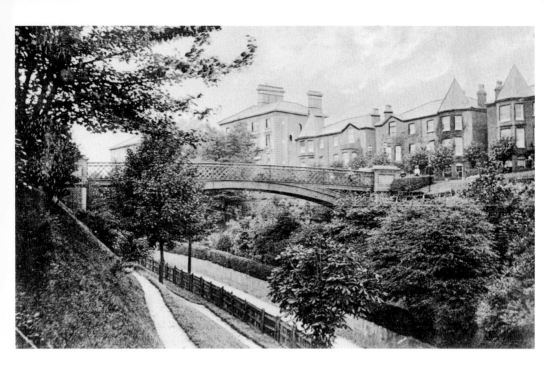

Jubilee Bridge

The Ravine Bridge spans the gaps between Belle Vue Park and North Parade. It was a gift to the town from the first mayor, William Youngman, and was opened on the 29 August 1887 to mark Queen Victoria's Golden Jubilee. In the second half of the nineteenth century, some fine townhouses were built on North Parade and the cliff top.

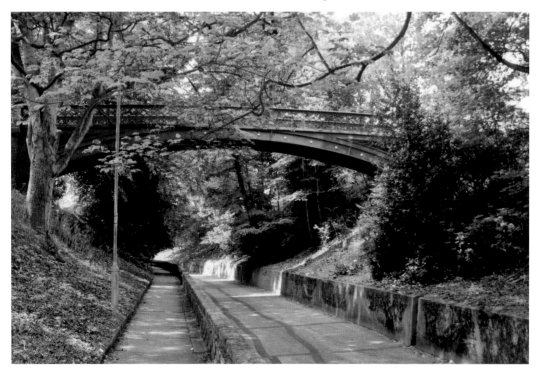

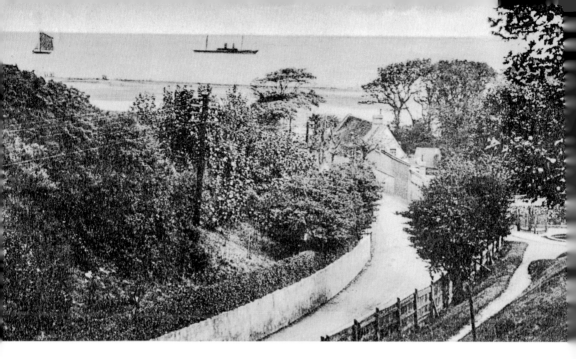

The Ravine

The growth of trees and greenery means it is no longer possible to experience the lovely view down the ravine to the shore and the sea.

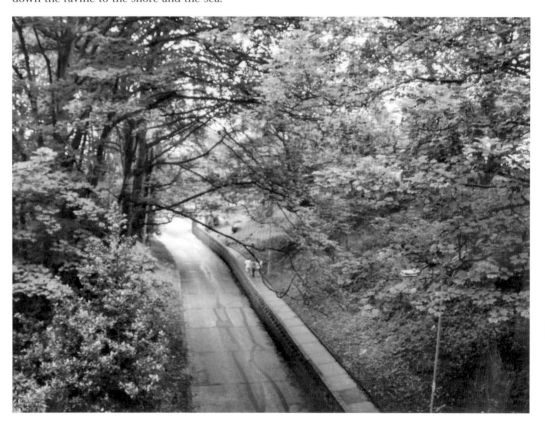

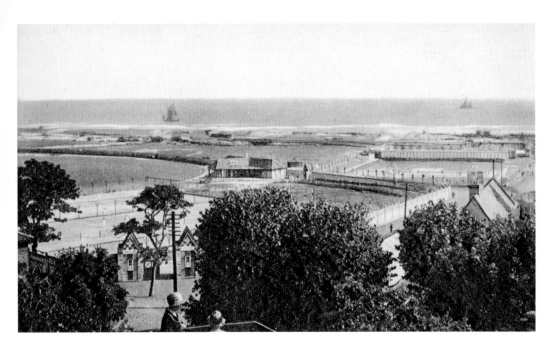

Lowestoft Recreation Grounds

This was the site of the town allotments, but in the 1920s and 1930s it was transformed into a recreation area. In 1924–25, tennis courts, a cricket pitch, a putting green and a swimming pool were set out. The swimming pool can be seen top right. The pool was made possible by the completion of the second north sea wall; water was pumped from an inlet on a groyne. During the war, the pool was used for naval training, but when the groyne carrying the inlet was washed away by heavy seas it was abandoned and eventually filled in for use as a caravan park.

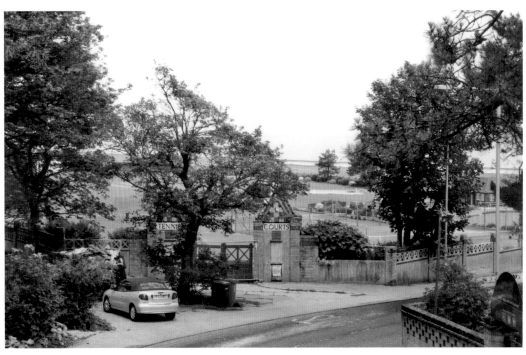

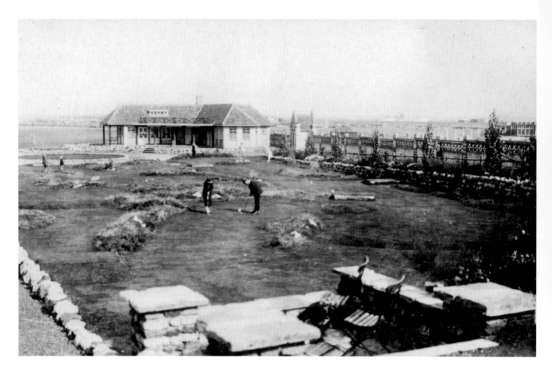

The Putting Green, North End

The putting green was one of the attractions of the recreation ground. There was also a children's playground and model yacht pond. Today the tennis courts and putting green provide facilities for the North Denes Caravan Park, which is approached by Swimming Pool Road, its name a reminder of what was once also there.

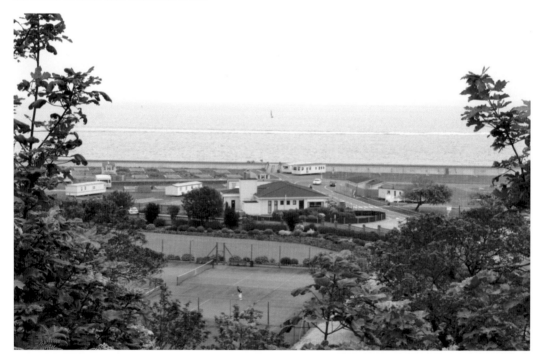

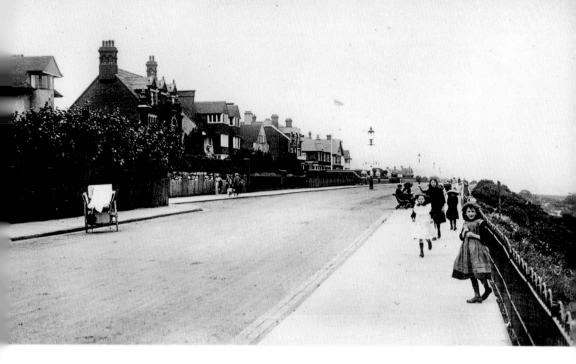

North Parade

North Parade overlooking the Denes. From the top of the cliff there are paths that run down through the trees and undergrowth to the Denes that stretch below. The road runs along Gunton Cliff onto Corton Road.

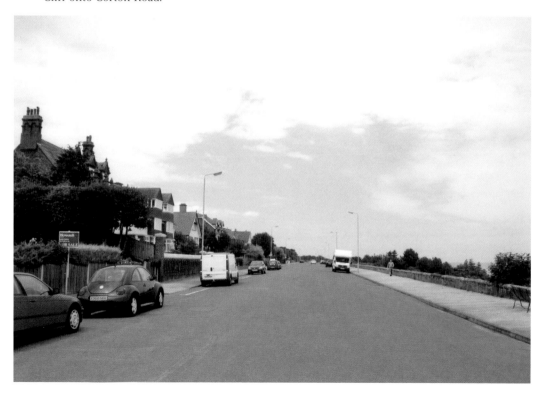

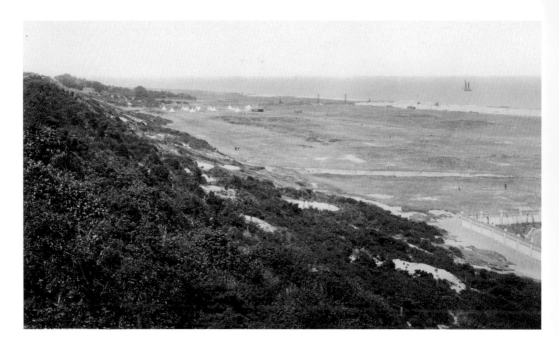

The Denes

In 1889 the Lowestoft Corporation bought the manorial rights to the Denes for the benefit of residents and visitors. For many years, part of the Denes was used as a links golf course – as the nearby Links Road, built in the 1920s, testifies. Today it provides a splendid walk towards the Corton sea wall and on to Hopton.

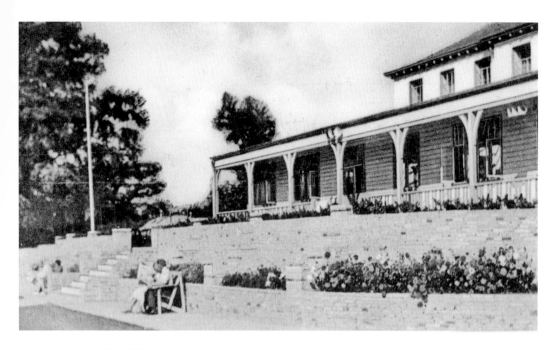

Gunton Hall Holiday Camp

This holiday camp, which still retains much of its original character, is off the A12 in a woodland setting. Originally the chalets were grouped around the hall. Gunton Hall was part of the Warners holiday camp business begun by Harry Warner in the early 1930s. In 1981 Warners sold to Grand Metropolitan and in 1987 Rank Leisure acquired Gunton Hall. It is now an adults-only camp.

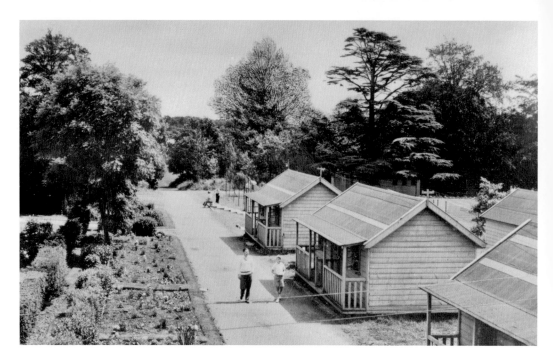

The Gardens and Chalets, Gunton Hall

Since these 1950s photographs, Gunton Hall has developed some superb facilities: a fitness studio, indoor bowls, pitch and putt, and a heated indoor swimming pool with sauna. I witnessed a game of shuffleboard for the first time while hearing distant shrieks from the totally different experience that is the nearby Pleasurewood Hills. Shuffleboard is apparently an ancient game and involves pushing quoits with a broom-shaped paddle along a narrow court and into the marked scoring area.

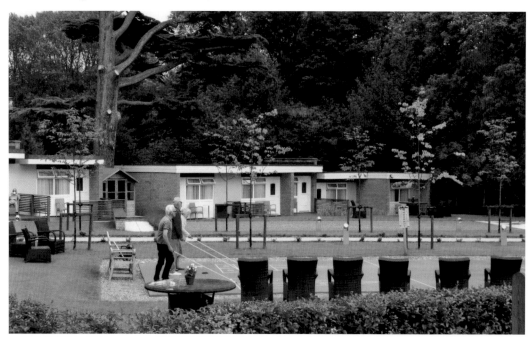

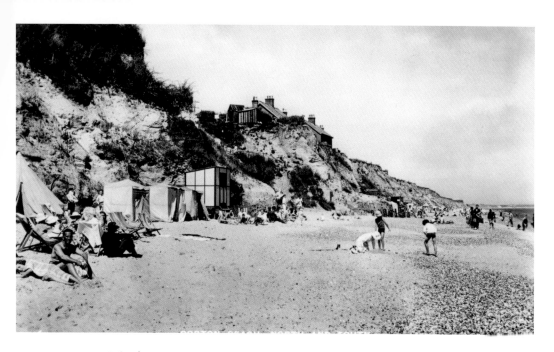

Corton Beach in the 1930s

Corton cliffs have suffered considerable erosion over the years. The crumbling state of the cliffs is clear from this photograph – a number of the buildings perched on the cliff top are at risk. Corton was, and still is, a popular place for holiday camps, with at least three in the immediate area. Solid wooden breakwaters and groynes limit erosion today. Jeremiah Colman, of the Norwich mustard firm, bought The Clyffe at Corton (inset) in 1869 and subsequently extended it. The erosion of the cliffs led to the house being demolished in 1917.

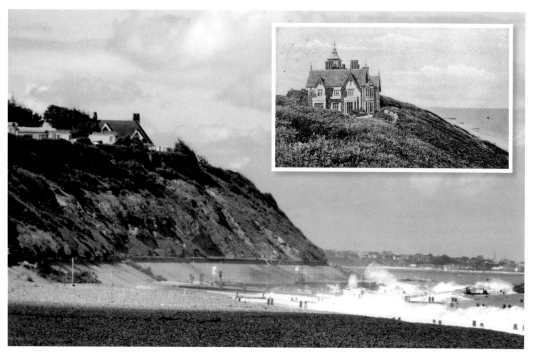

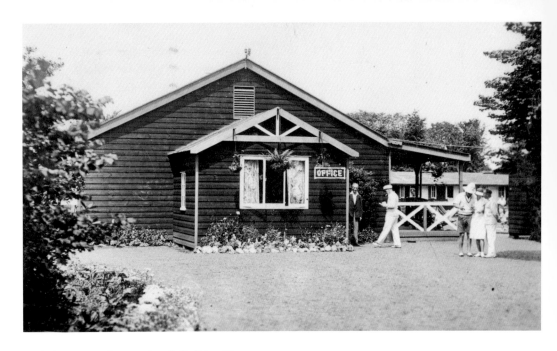

Main Entrance, Corton Beach Holiday Camp

In 1924 the Clyffe estate was purchased by W. J. Brown MP, founder of the Civil Service Holiday Association. He built the Corton Beach Holiday Camp. Corton typified the 1920s holiday camp with its wooden chalets and the emphasis on sport and recreation. In 1946 Warners acquired the holiday camp as part of its growing empire. Gradually the camp changed, with the old wooden chalets being replaced by brick one- and two-storey units in the 1980s. Now known as Waterside Park, it is part of the Hoseasons Group.

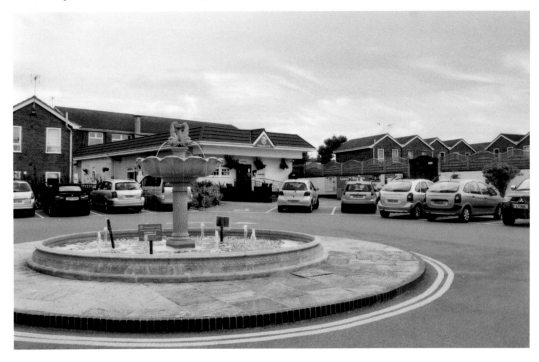

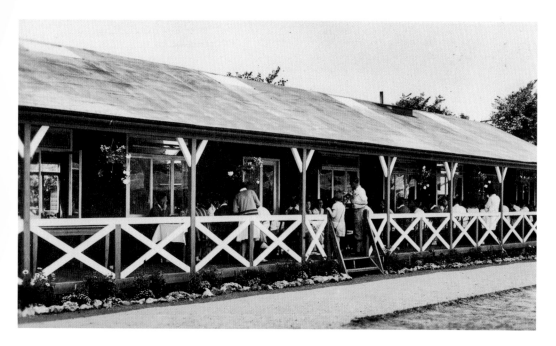

The Verandah

Today there appear to be two camps occupying the old Civil Service Association site. The Warner Corton Coastal Village offers adult holidays like Gunton Hall. Corton offers relaxation, stunning coastal views and entertainment, all on site. The old association with the Colman family is retained in the use of the name The Clyffe for the cabaret diner. All the old wooden huts have long gone, replaced by brick accommodation.

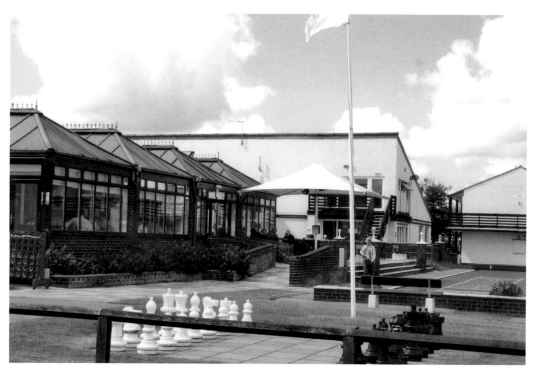

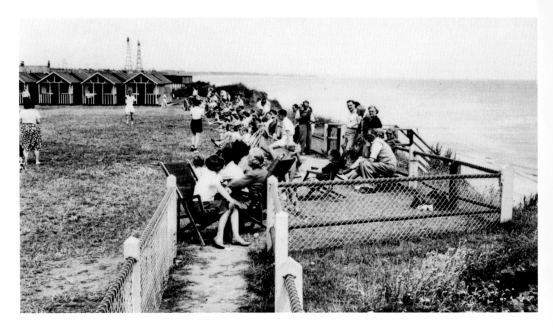

Corton Beach Holiday Camp

Today's photograph is of the Waterside Park lounge bar and restaurant. There is a still a cliff top staircase from the Warner Coastal Village down to the sea wall and the sands below. Fences stop anyone getting too near the cliff edge.

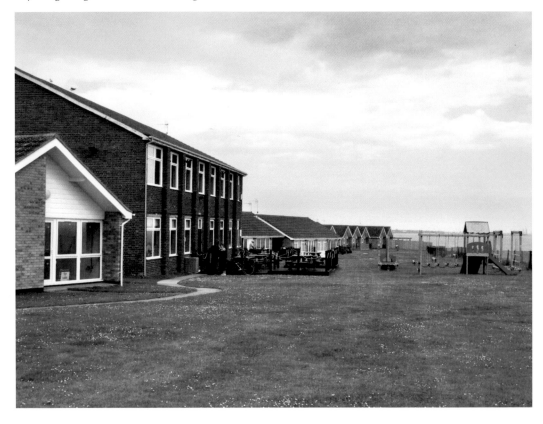

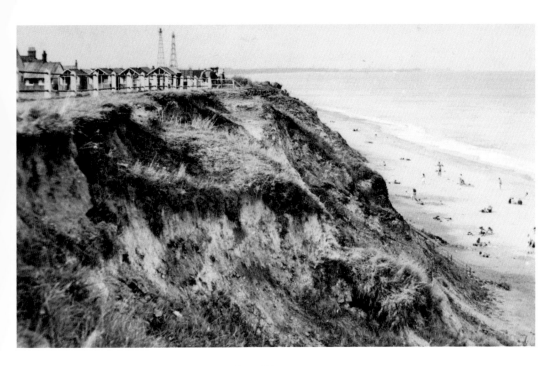

The Cliffs and Sands at Corton Beach Holiday Camp

The distant pylons in this 1950s photograph indicate the location of RAF Hopton. The twin pylons were part of Britain's radar defences during the Second World War. RAF Hopton was between Corton and Hopton, on the cliff top. The RAF left in the 1950s and the site has been in private hands since 2000. Today's photograph is actually from the top of the cliffs at Broadlands Sands, north of Corton. It shows how unsafe the cliffs are on this stretch of coast. The line of sea defences is an attempt to prevent further erosion.

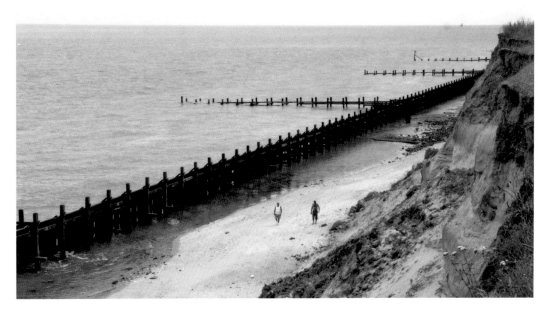

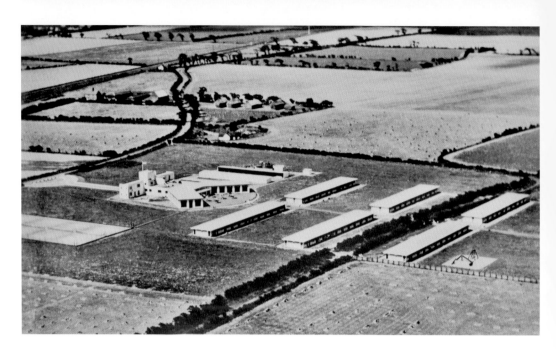

Rogerson Hall, Corton

One of the pioneering holiday camps, Rogerson Hall was opened in 1938 by the Workers' Travel Association to provide affordable holidays for workers and their families. The design was striking, with a main building and blocks of chalets leading down to the cliffs and the beach. This design was to encourage a community feeling in the chalet blocks.

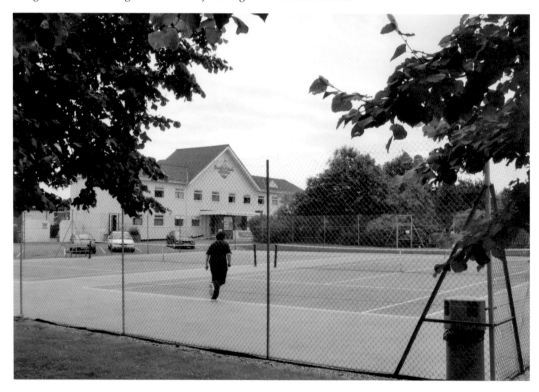

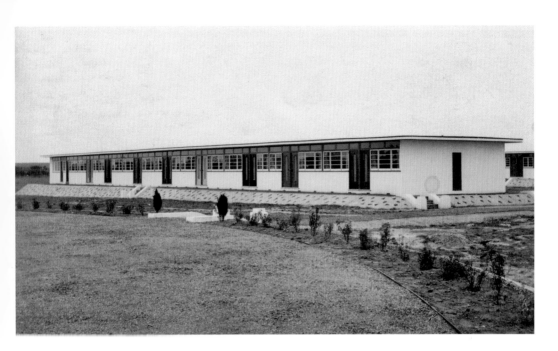

The Chalets, Rogerson Hall

Today Rogerson Hall is called Broadlands Sands and is operated by Hoseasons. While the main building is recognisable, the whole site is dominated by luxury caravans. There is a splendid outdoor pool, tennis courts and a clubhouse with entertainment. Caravans at the cliff end of the camp enjoy wonderful sea views, but the cliff edge is dangerous and fenced with warning signs about the danger of cliff falls.

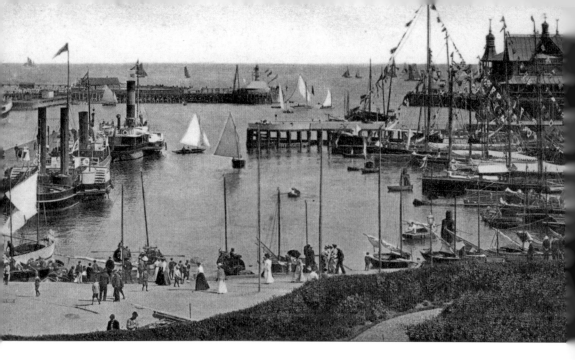

The Yacht Basin and Harbour

Returning to the harbour area at Lowestoft brings us back to Sir Samuel Morton Peto and the development of the modern resort on the southern side of the bridge. In Edwardian times the yacht basin was open for locals and visitors to go down to the rowing boats and yachts and paddle steamers. It was obviously an area full of colour and activity.

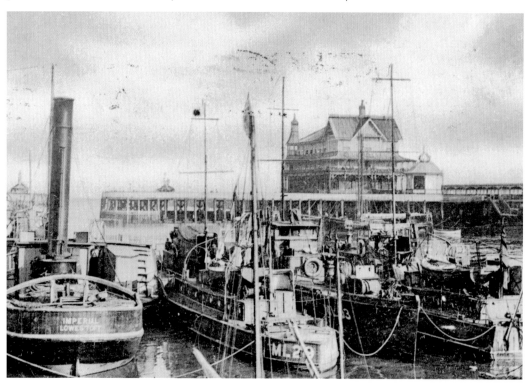

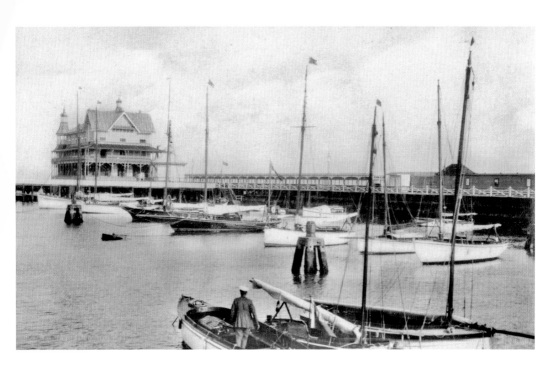

The Yacht Basin (I)

The old pavilion has gone and the modern replacement, the RNLI building, does not have the same impact on the skyline. What is noticeable today is how difficult it is to capture the old views. It is not just the amount of traffic on the bridge; it is also the high security fences that encircle the area, since there are so many valuable yachts with expensive equipment moored there. This photograph was taken through the security fence.

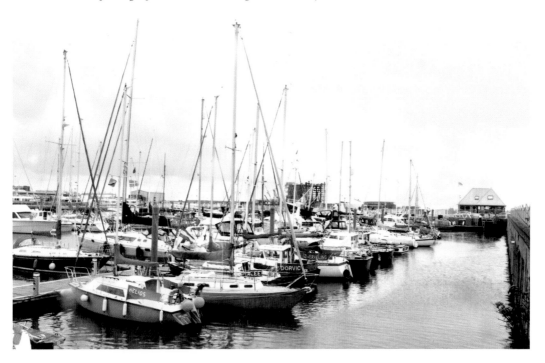

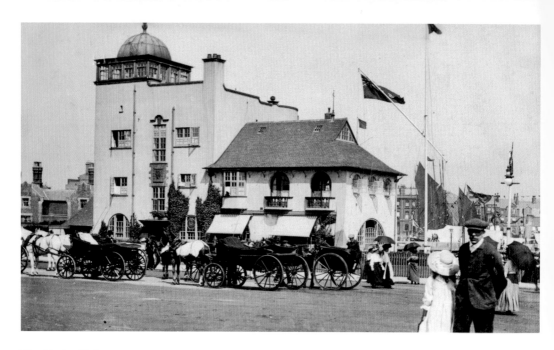

The Yacht Club

Seen here before the First World War, the Royal Norfolk and Suffolk Yacht Club, designed by G. & E. Skipper, was opened by Sir Claud Hamilton in 1903. The yacht club was formed in 1859 and this striking building replaced an 1880s wooden pavilion. When Robert Reeve, the Lord of the Manor, died, the rights to the area were donated to the Lowestoft Corporation. A monument erected to Reeve in 1891 was replaced by the 1921 cenotaph; the Reeve memorial now stands in Kensington Gardens. The popular dancing fountains were installed in 2006.

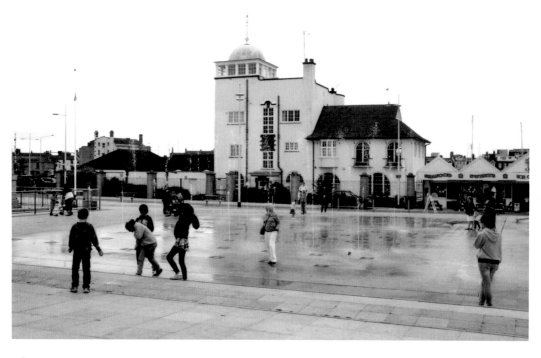

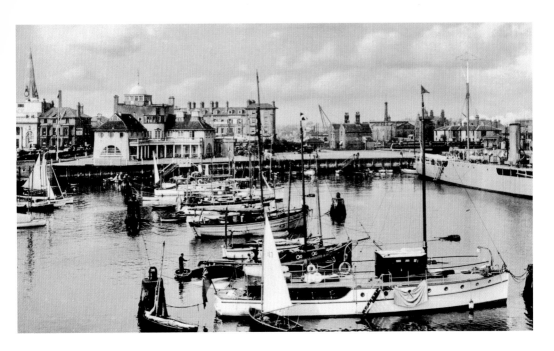

The Yacht Basin (II)

A classic view from the South Pier with the corner of the Palace Cinema – built over the Royal Mews and lost in a fire in July 1966 – visible on the far left. The rear of the yacht club and the familiar skyline behind are immediately recognisable, but many of the industrial buildings beyond the bridge have gone. The spire of St John's church has also gone. The church, built by Samuel Morton Peto to serve the new community, was declared redundant and demolished in the 1970s.

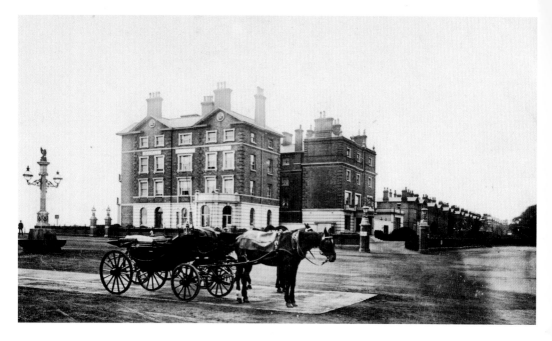

The Royal Hotel

Samuel Morton Peto had ambitions for Lowestoft that went beyond bringing the railways to the town and developing the port. He saw the town as becoming another Brighton. In 1846 he bought an area of wasteland and farmland south of his new harbour, running up towards Kirkley. With his architect, John Thomas, and builders the Lucas brothers, he began to construct the Marine Parade and the Esplanade. The Royal Hotel opened in 1847.

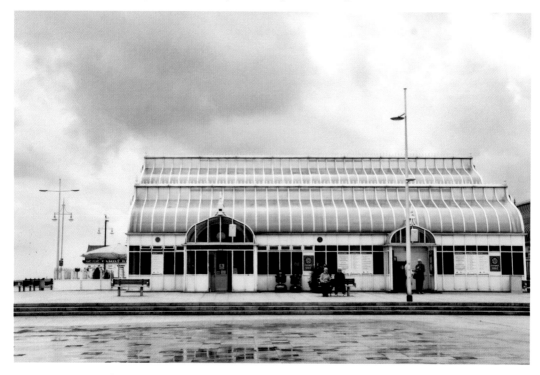

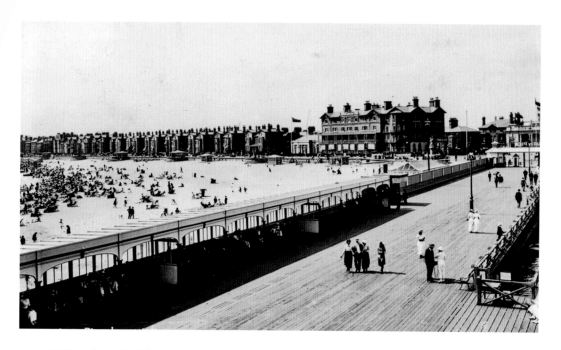

A View from the Pier

It is 1925 and the pier seen from the pavilion provides a fine promenade. A long line of elegant shelters protects the visitor from the wind. Seated here, holidaymakers could listen to the band or just enjoy the fresh air and the view of the yacht basin. The Royal Hotel and the row of villas along the Esplanade are an impressive sight along the seafront.

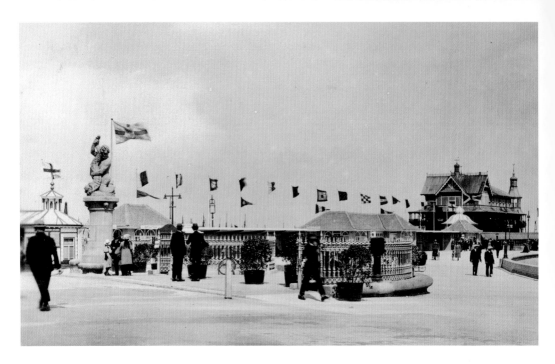

The South Pier and Pavilion

The Royal Hotel looked out towards the new harbour and the South Pier, which was opened as a promenade. Victorian and Edwardian holidaymakers could watch the fishing boats leaving the harbour and returning with their catch. Small pleasure boats often went out to give visitors a better view of the fleet. In 1885 the original pier and the small pavilion were lost in a fire. This pier was built in 1888–89 with a splendid new pavilion put up in 1891 with a bandstand nearby.

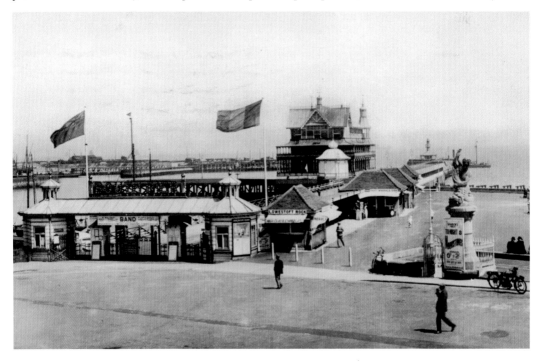

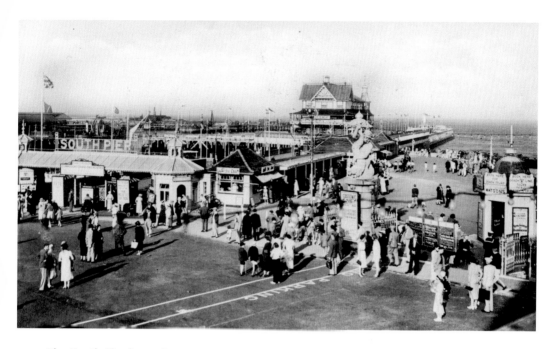

The South Pier in 1938

The resort was at its height in the 1930s, with the South Pier one of the major attractions. Harry Davidson's Grand Commodore Orchestra is advertised, as well as 'The Mad Hatters of 1938'. At the Sparrow's Nest you could see 'Red Hot and Blue Moments'. Watsons coach tours could be booked to take holidaymakers across Norfolk and as far as the gardens at Sandringham.

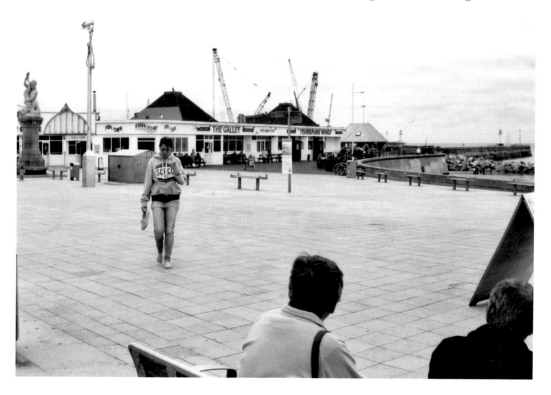

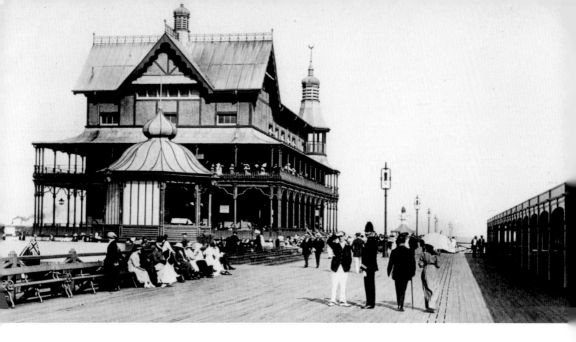

The South Pier

This was the epitome of Victorian pier pavilions; its balcony gave views around the harbour and along the beach. During the First World War it was the commanding officer's headquarters for the Royal Naval Patrol Service. Sadly, in 1954 it was demolished. The replacement building was an entertainment centre with two dance floors, a theatre and restaurants. There was also the 'Space Tower', which gave even better views of the surroundings.

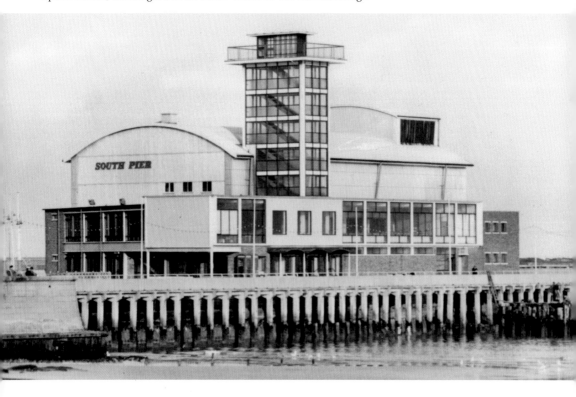

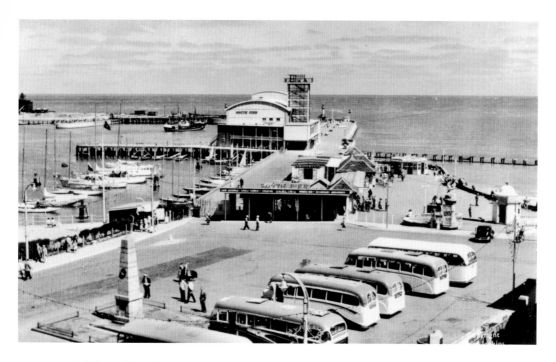

Royal Plain and South Pier

Many local people and holidaymakers recall the South Pier Pavilion, in particular its dances and entertainment, with great fondness. It was demolished in 1989 and eventually the new lifeboat station was built on the site in 1999. The whole area in front of the pier has been laid out as a pedestrian precinct.

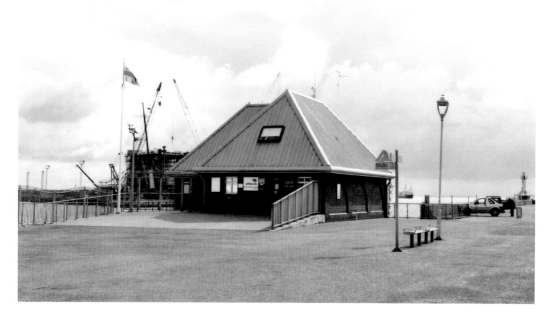

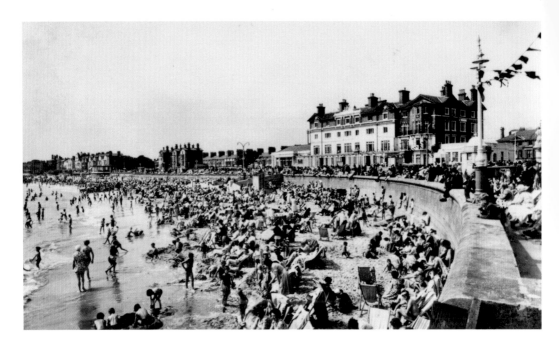

Children's Corner

This photograph shows just how popular Lowestoft was in the 1950s. The crowds flocked back to the seaside after the Second World War, when Lowestoft had been almost completely taken over by the Royal Navy. Being the most easterly part of the country and a port, Lowestoft suffered damage during the war. The buildings lost along the seafront added to those demolished by the council in the 1930s as it began to create gardens and car parks.

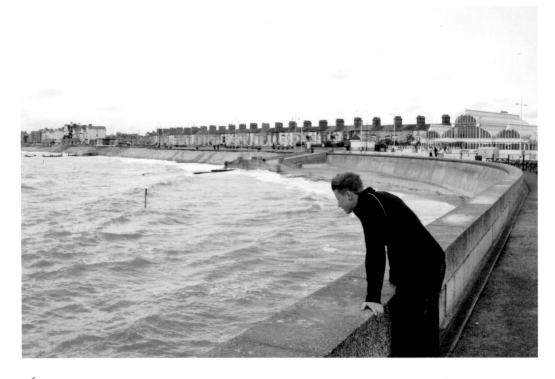

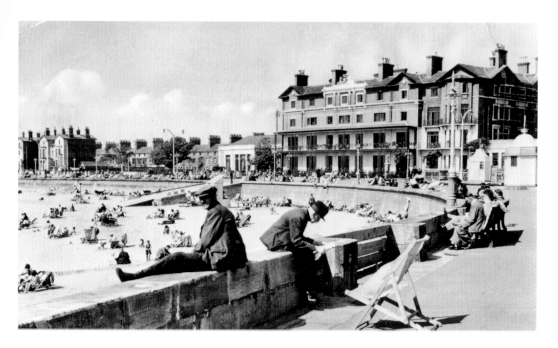

The Royal Hotel and Esplanade

Peto's showpiece hotel – which was so successful that it was enlarged soon after it opened – catered for the gentry staying in the growing resort. In the 1880s Clement Scott described Lowestoft as 'the cleanest, neatest and most orderly seaside town'. King George V visited the Hotel in 1916. During the Second World War it became HMS *Mantis*, but it fell on hard times and was eventually demolished in 1973. The East Point Pavilion opened on the site in May 1993. The hotel's coat of arms can be seen inside the Tourist Information Centre there.

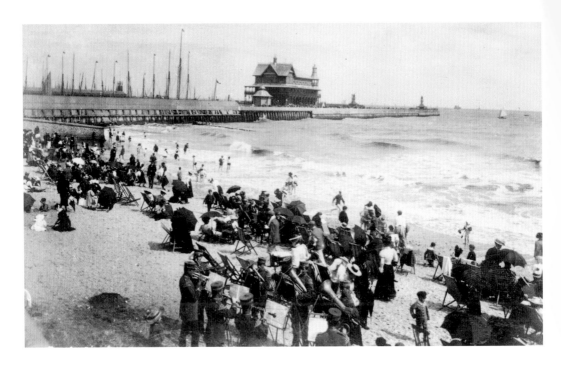

Beach and Pier

Popularly known as Children's Corner, this part of the south beach is sheltered by the South Pier and was a favourite area for entertainers. A small band is playing on the sands, although not many people seem to be listening. Everyone is well protected from the sun. Before the First World War, Will Edwards and his concert party had a stage on the beach, known as the South Beach Pavilion, but it was destroyed by a storm on 11 September 1912. Punch and Judy shows entertained the children here for many years.

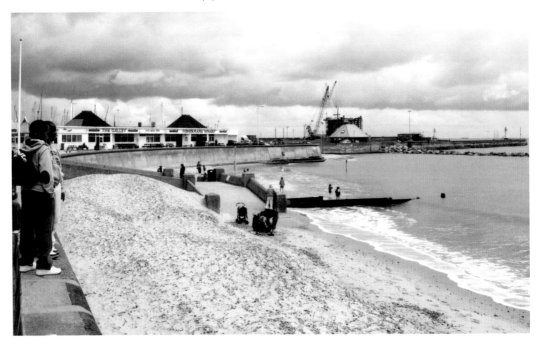

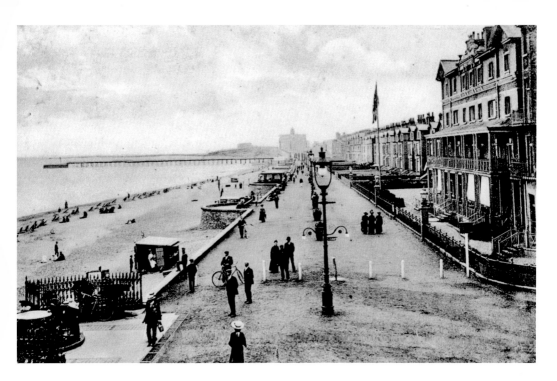

The Esplanade (I)

It is 1910 and one 'ED' is 'having a most lovely time'. This fine photograph shows how Samuel Morton Peto's vision was realised. The Royal with its balconies sits at the head of the Esplanade and the terrace of villas, with their front gardens, stretches southwards. A series of semi-circular bastions punctuate the Esplanade. The Esplanade has been widened over the years, just as most of the villas have been demolished. The Royal Green now replaces many of the Victorian villas. The modern lampposts echo the original.

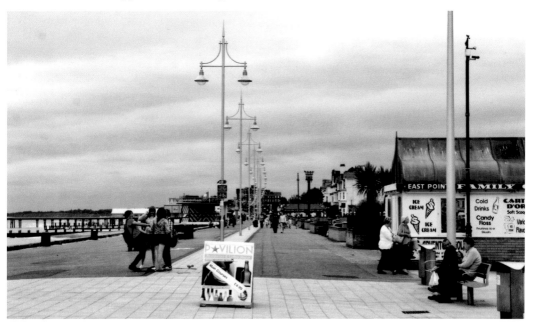

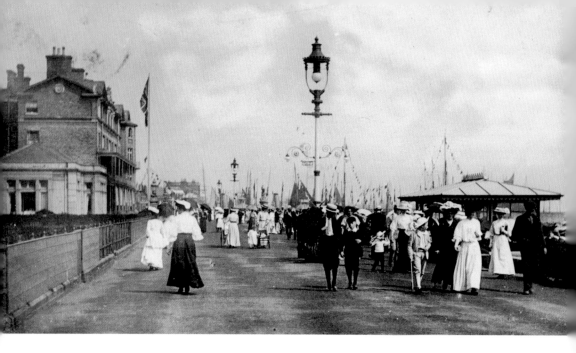

The Esplanande (II)

Holidaymakers pass by the front of the Royal Hotel *c.* 1910, when the card was written: 'I wish you were here with us, this place suits us splendidly. The weather has been glorious and we are getting so brown.' It is difficult to imagine how – everyone is so covered up.

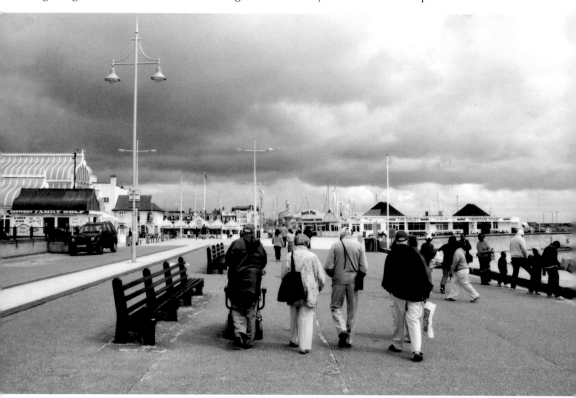

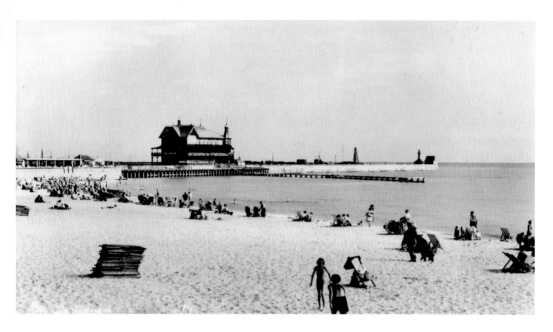

South Beach (1)

The beautiful sea-washed sands have long been a popular feature of Lowestoft. In this early 1950s photograph you can see the South Pier Pavilion, which was later demolished. Today, quite rightly, the resort is proud of its Blue Flag status and the council takes great care of its beaches. The movement of the tides is creating sand hills against the Esplanade wall, providing an entertaining climb for children.

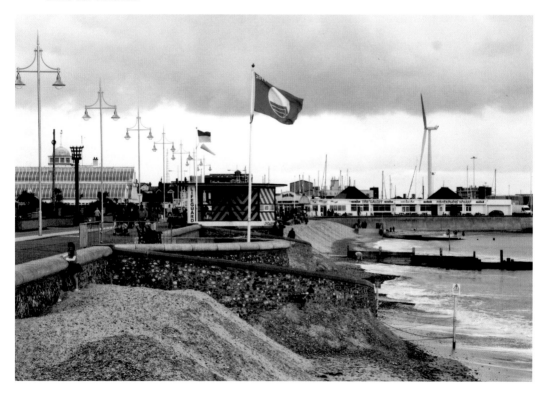

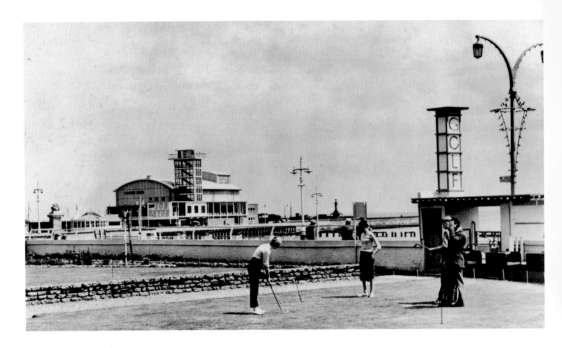

Esplanade Putting Green

In the 1950s there were various attractions along the Esplanade. The putting green has been replaced by a hard surface with a children's battery-powered car track and a play area. A popular model railway circled the area until the 1970s. The Royal Green now covers most of the area, and a new family golf course has been created next to the East Point Pavilion.

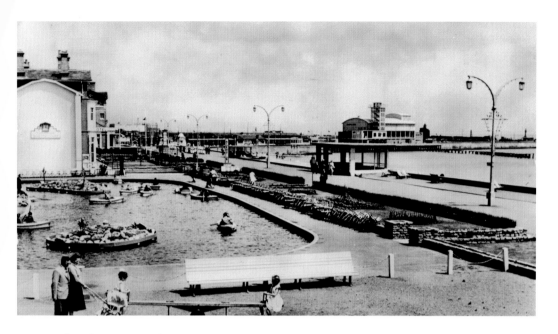

Esplanade Boating Lake

For a while in the 1950s the boating lake was a popular attraction, but it was filled in when the Royal Plain grassed area was laid out. The 2011 photograph demonstrates the ruthlessness of the clearance that made room for the grassed area and the adjoining car park.

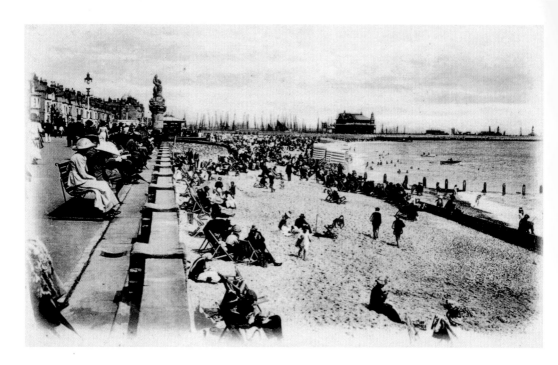

The Beach and Promenade

Another Edwardian photograph illustrating the popularity of the resort. There are bathing machines and a rowing boat patrolling the swimming area. There had been bathing machines at Lowestoft since 1768. Peto's terrace of villas can be seen and the statue of the Greek sea god Triton holding a cornucopia (i.e. a horn of plenty). The statue survives, unlike many of the villas.

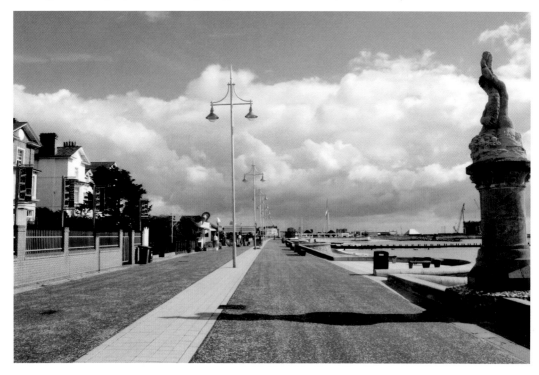

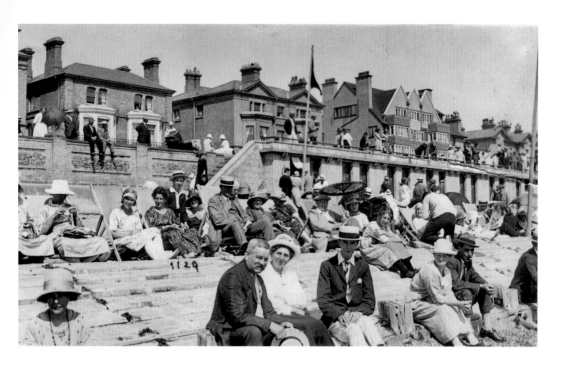

South Beach (II)

While not all change is for the better, for some reason in 1980 I took this photograph of some shelters and what look like changing cubicles along the Esplanade between Hatfield Hotel and the beach (inset). The Hatfield has been renovated and these shelters have been taken away as part of the improvements to the seafront. The view is better for it.

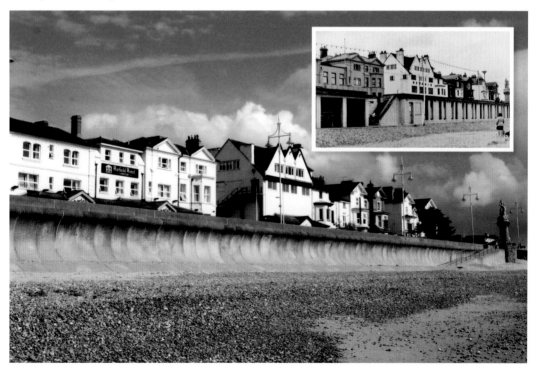

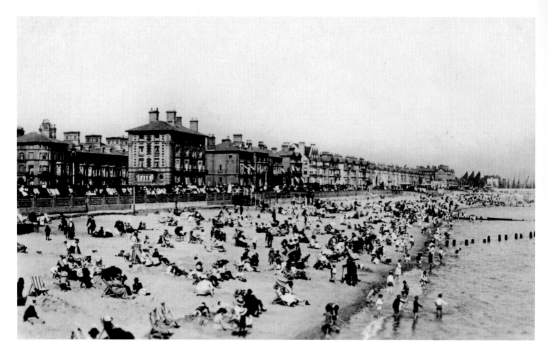

The South Beach and Esplanade (1)

The creation of the Royal Green cleared many of Sir Samuel Morton Peto's original buildings. The large buildings on the left next to the Wellington Gardens were Blenheim House and Aspley House, which in 1920–55 were used by the Ministry of Agriculture, Fisheries and Food. In 1992 the prominent Sir Morton Peto House was built as a supported housing scheme run by the Orwell Housing Association. The modern building reflects many of the features of the old building.

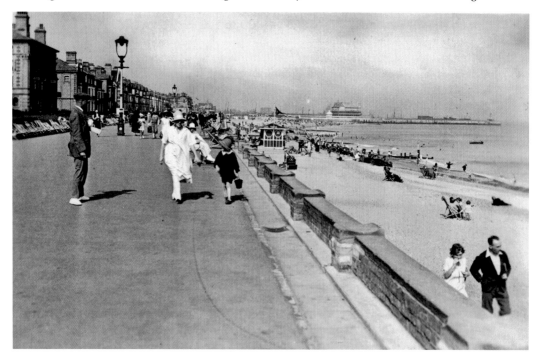

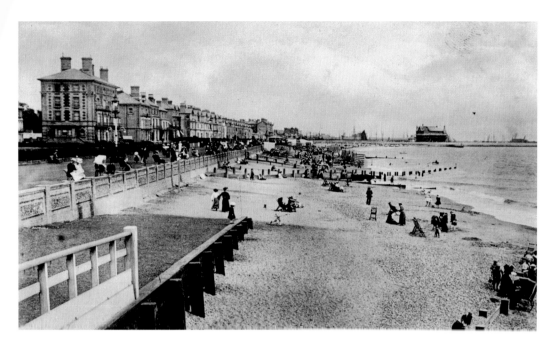

The South Beach and Esplanade (II)

It is mid-July and there is a blue evening sky with piles of fluffy clouds. The waves are breaking gently on the beach. In the distance a launch turns into the harbour entrance. There are a few children enjoying the beach and a few surfers are riding the rolling waves, but mostly it is the gulls strutting and squawking around Claremont Pier that are making the noise. There is an endless horizon of sea.

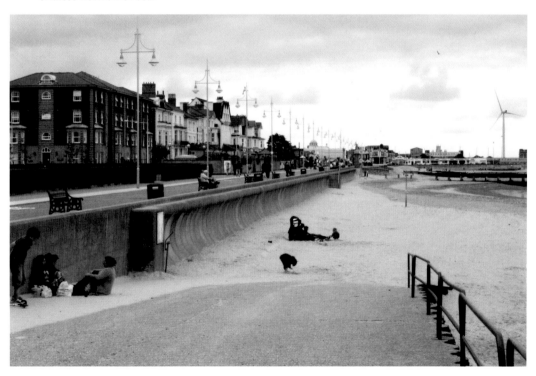

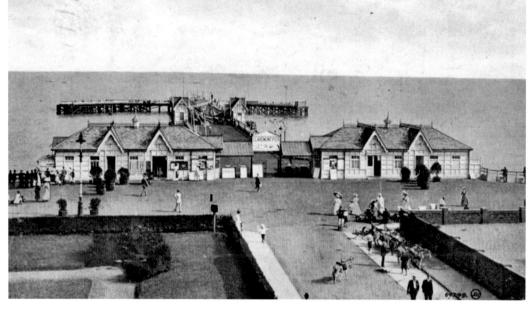

Claremont Pier (1)

Claremont Pier was constructed by the Coast Development Company, who owned the Belle steamers, and opened in 1903. It was used by the Belle steamers as they went round the coast from London to Great Yarmouth. At first the pier was 600 feet in length, but it was extended in 1912 with a T-shaped landing head. The last time boats used the landing stage was in 1939, when evacuees were brought from London. Like other east coast piers, the middle section was blown up in 1940 as fears of a German invasion grew.

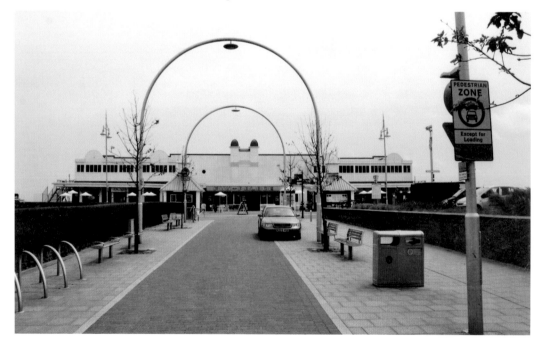

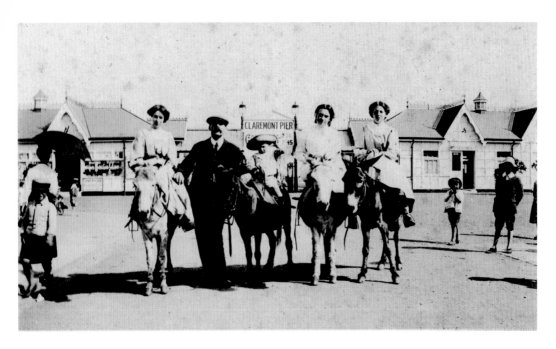

Claremont Pier (II)

The army retained the pier as a training centre until 1948. Left in a very poor state, it was rescued by the actor George Studd, who bought it, carried out repairs and built a new concrete platform and pavilion. In 1962 the T-shaped landing head was washed away. Today the pier is an entertainment centre, with night club, amusement arcade, restaurant and roller-skating rink. Where once 'Donkey' Jones gave donkey rides to holidaymakers, the approach has been attractively refurbished and there are some great ice creams to enjoy.

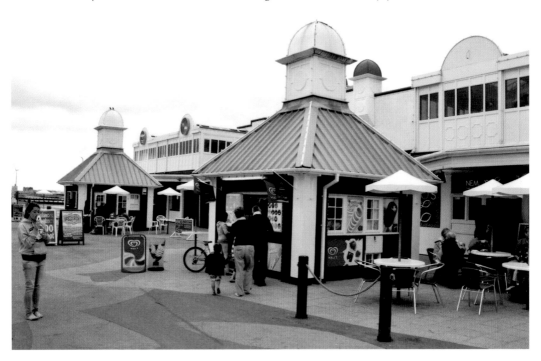

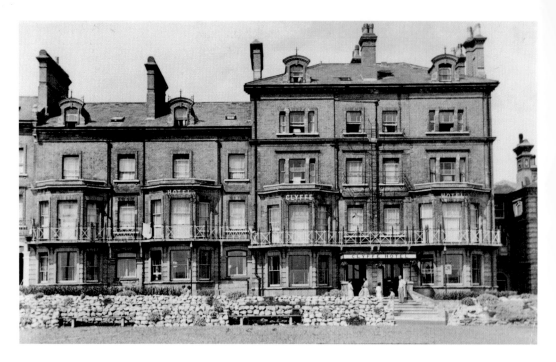

The Clyffe

The Clyffe Hotel, part of John Thomas's architecture for the seafront, makes a bold statement at the end of a splendid terrace of townhouses. Several of them, like Somerton House, offer bed and breakfast and it is possible to enjoy the high ceilings and practical elegance of Samuel Morton Peto's Lowestoft. The Clyffe in 2011 is closed for renovation.

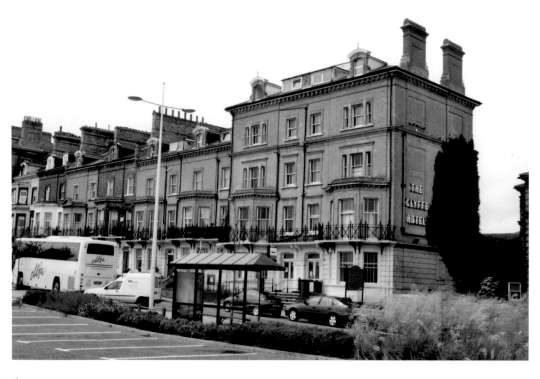

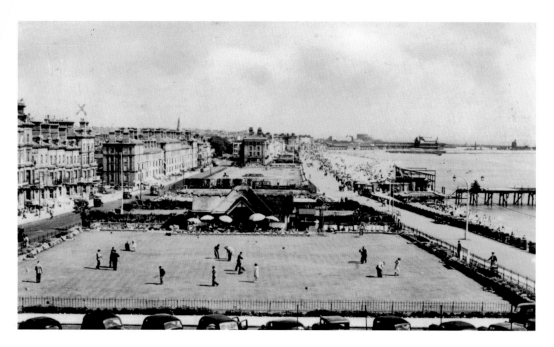

The Putting Green

As well as showing the putting green in the late 1940s, this postcard shows what appears to be reconstruction work on the Claremont Pier. The sender of the card has marked The Clyffe, where they were staying. Today The Thatch is a restaurant in the 'Yummy Lowestoft' group that also includes the Martello's at the Sparrow's Nest and the East Point Pavilion Restaurant.

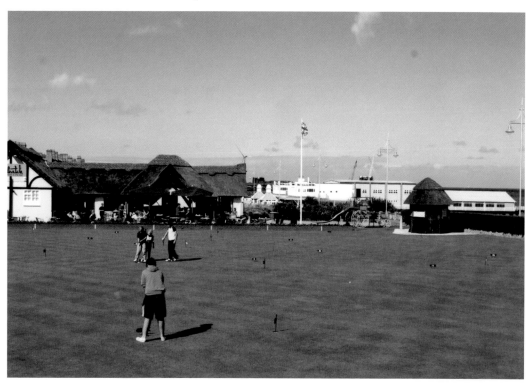

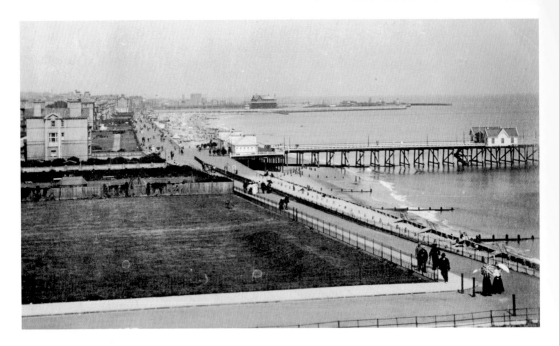

Lowestoft c. 1919

This photograph was taken from Victoria Mansions across where the putting green and The Thatch are today. The large house prominent on the left is South Lodge Preparatory School, where Benjamin Britten was a pupil in the early 1920s. Britten was born at 21 Kirkley Cliff, so he would have had only a short walk from his dentist father and music-loving mother's house. Today his old home, Britten House, offers accommodation to visitors. His old school building, however, was demolished after the school moved to Old Buckenham Hall in the late 1930s. The site is now a car park.

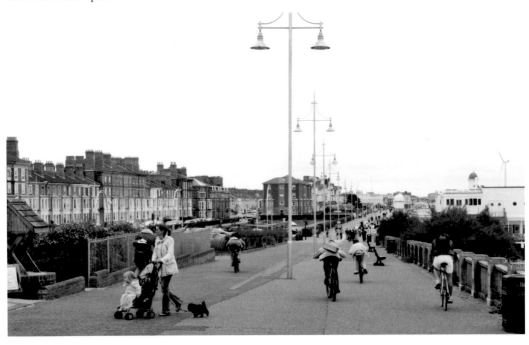

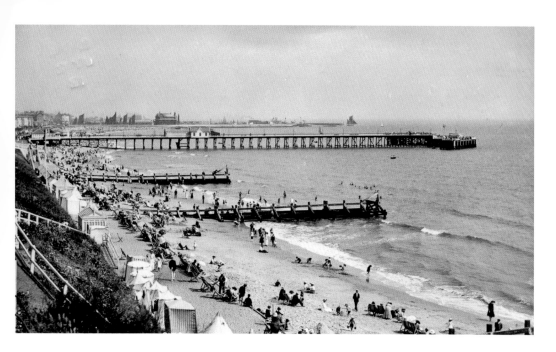

Claremont, Lowestoft

The cliffs at Kirkley were seriously damaged by very heavy seas on 10/11 September 1903. The first parade put in by Peto was washed away. New groynes and sea defences were put in place and a few years later this section of the beach was greatly improved with a lower parade and an upper esplanade. This photograph was taken *c.* 1912, when 'Alice' wrote to Winchmore Hill, London: 'We are here for a little while to see what a complete change will do for me.'

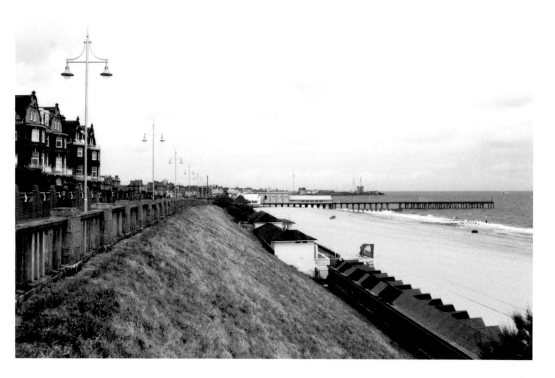

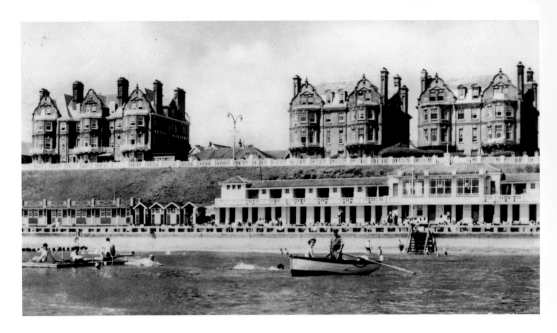

New Promenade and Victoria Bathing Chalets

George Skipper designed the Victoria Hotel and Victoria Mansions on the cliff top at Kirkley and they marked the Diamond Jubilee of Queen Victoria. The hotel boasted fifty well-furnished rooms and a Turkish bath. The first bathing chalets replaced the various tents in the 1920s and were later given an upper storey. The Kirkley Hotel is on the right.

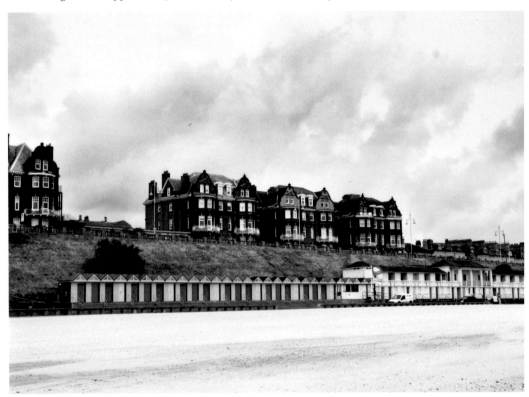

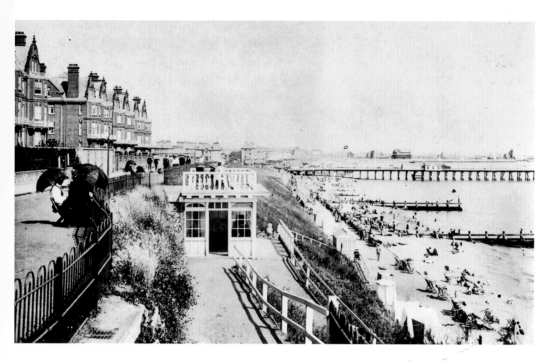

Kirkley Cliffs

A delightful Edwardian view looking towards the Victoria Hotel and Victoria Mansions. The two ladies sitting on the Esplanade are in no danger of getting too much sun, while the neat little shelter with the railed deck has gone. The bathing area below was clearly defined between the groynes and patrolled by a rowing boat.

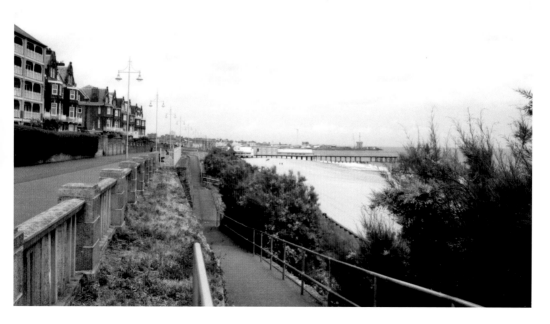

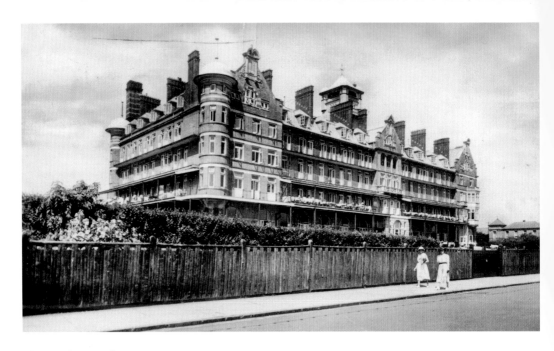

The Empire Hotel

The Victoria Hotel was soon dwarfed by the vast Empire Hotel, which opened in 1900. The hoteliers, Spiers and Pond, spared no expense on this 200-bed hotel, described as one of the finest in Europe. It was lit by electricity and there were lifts to all floors. There was a grand hall with orchestral gallery, library and a billiards room. Outside, in the grounds, guests could play tennis, croquet or bowls. Sadly the Empire was short-lived as a hotel and in 1921 it was bought by the Metropolitan Asylums Board of the LCC and in 1922 reopened as St Luke's Hospital for the treatment of tuberculosis.

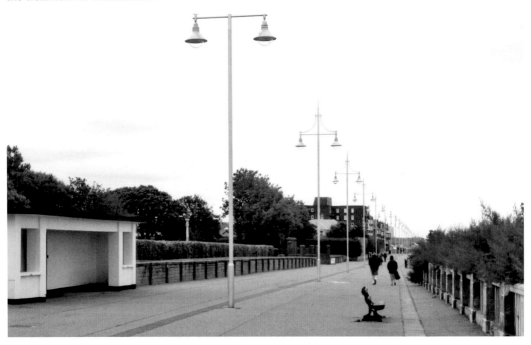

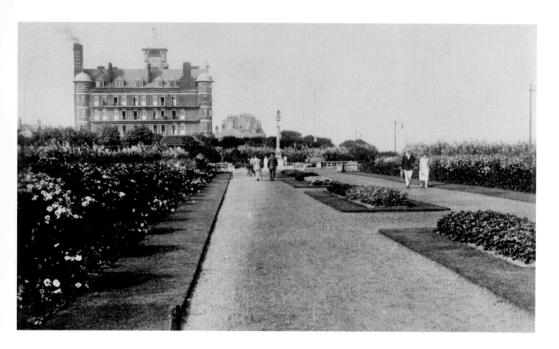

Kensington Gardens (I)

In 1914 Lowestoft Town Council bought a large area of farmland at the top of Kirkley Cliff. After the First World War five acres were laid out as Kensington Gardens in a work-creation scheme. The gardens included a Japanese rock garden, a tea house, an ornamental lake, tennis courts, and bowling and putting greens. There was also a sunken bandstand and rose gardens. The Reeve monument, removed from the Royal Plain in front of the yacht club, was given a new place of honour.

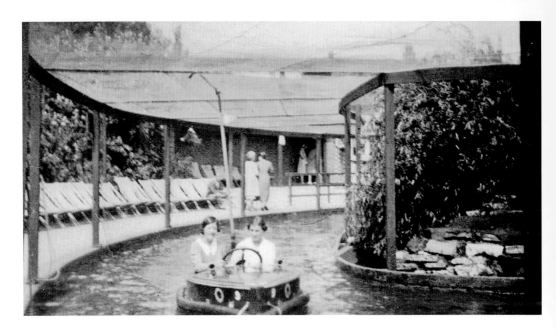

Electric Boating Lake, Kensington Gardens

The sunken bandstand was transformed into a real novelty between the wars when it became the electric boatway. Rather like floating dodgems, the boats were powered by contact with an overhead canopy. This holiday photograph was taken in 1936. The boatway was still there in the late 1970s, but today it is a more mundane small boating lake for self-propelled canoes – which can still be great fun.

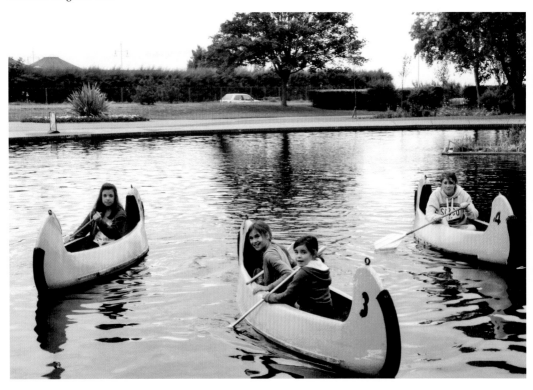

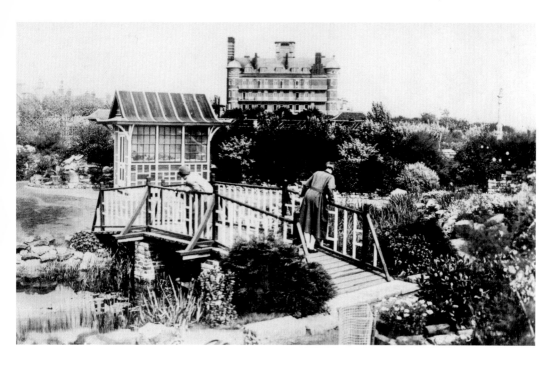

Kensington Gardens (II)

This is a lovely pocket of calm. The Japanese gardens do not really look Japanese as the pagoda has gone, but there is still a bridge and the chance to look down on all the goldfish swimming around the small waterway. There are seats among the rocky flower beds and all the trees have grown to make it a very green and shaded spot.

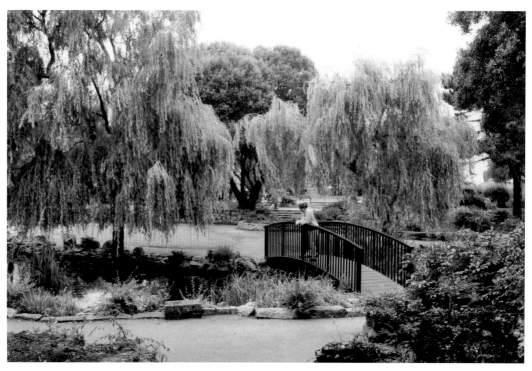

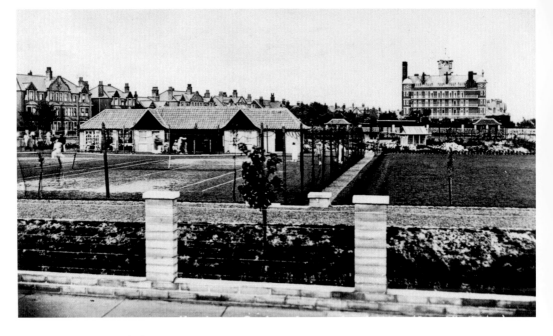

Kensington Gardens (III)

Beyond the gardens, St Luke's Hospital dominates the skyline. During the Second World War the building was requisitioned by the Royal Navy for its engineering and stoker training. After the war it remained empty until 1958, when it was bought by St Mary's Convent, which was next to the Victoria Hotel. The site later became a playing field and tennis courts. St Mary's Roman Catholic Primary School was built here in 1967, with Shaftesbury Court joining it in 1989.

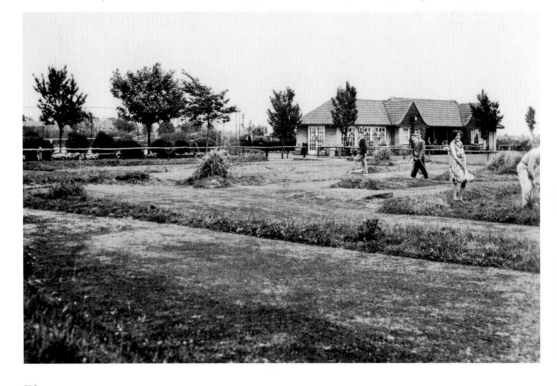

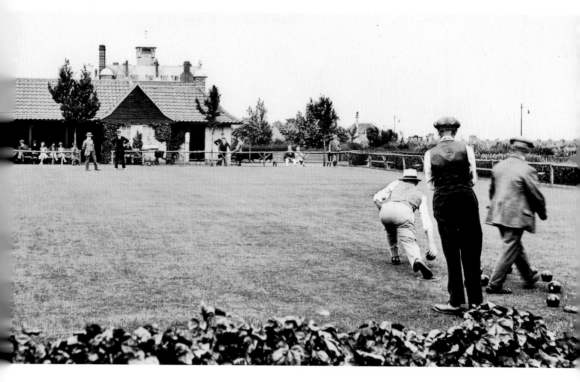

Kensington Gardens (IV)

The putting green has gone and the bowling green has been extended. There are still tennis courts and there has been some refurbishment of the facilities over recent years.

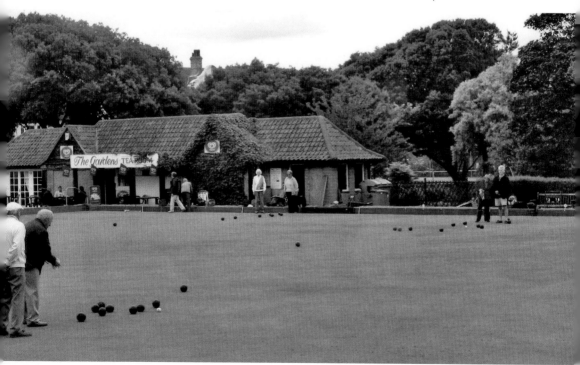

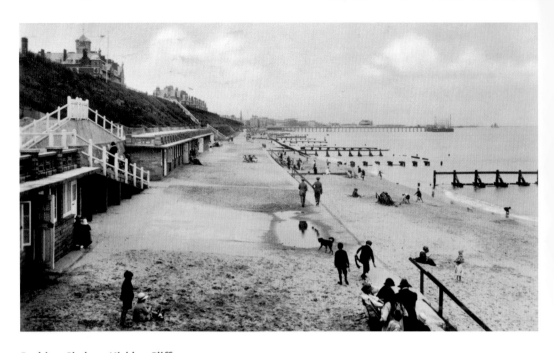

Bathing Chalets, Kirkley Cliffs
St Luke's Hospital can just be seen on the cliff top in this photograph of *c.* 1930. Kirkley's seafront now runs into Pakefield. The Grand Hotel is somewhere not far above this scene.

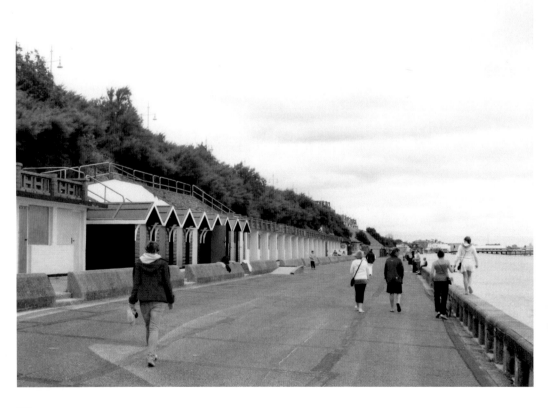

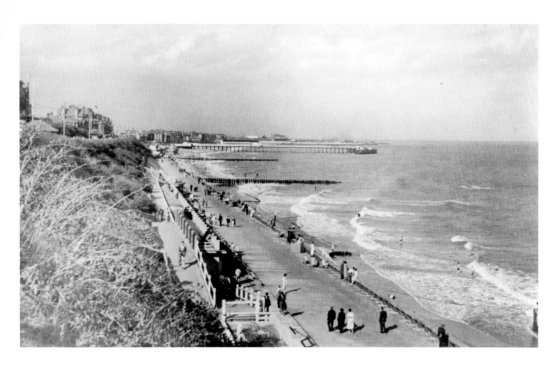

New Promenade
There was a steady procession of families along the promenade while we were there in July enjoying the walk between Pakefield and Lowestoft. This was an area of serious cliff falls in September 1903, which led to a great strengthening of the sea defences.

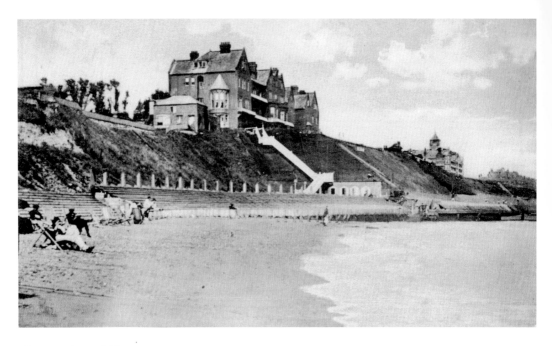

The Grand Hotel (I)

The Grand Hotel was built in 1893 by John Whaley, incorporating Holm View, a mansion with established gardens between Pakefield Road and the cliffs. There was room for 140 guests. From its cliff-top gardens it had its own steps down to the promenade and the beach. The Grand was protected by its own sea defences and was undamaged by the 1903 storm. In 1931 the Empire Hall was added to the hotel. Only a 1980s government department could have added the carbuncle to the right.

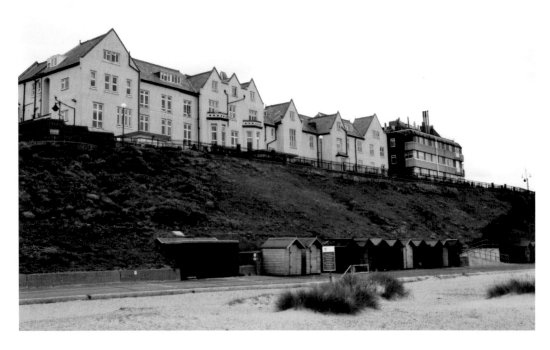

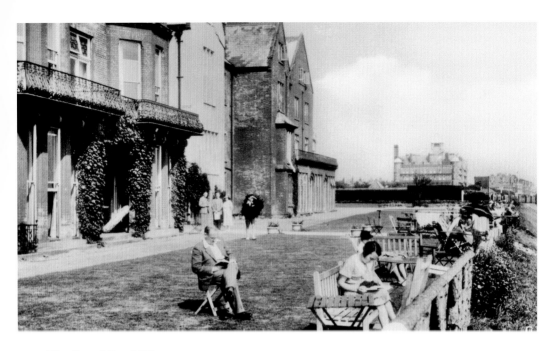

The Grand Hotel (II)

The Empire Hall was large with a seated capacity of 2,000. It was a popular dance hall and also staged boxing and wrestling events. It was known as the Palais de Danse and was particularly busy during the Second World War with all the servicemen stationed in and near Lowestoft. This included American servicemen, who were popular with the local girls. Soon everyone was learning the American jitterbug and jive. It is still possible to take a shot of the old hotel, albeit through the security fencing.

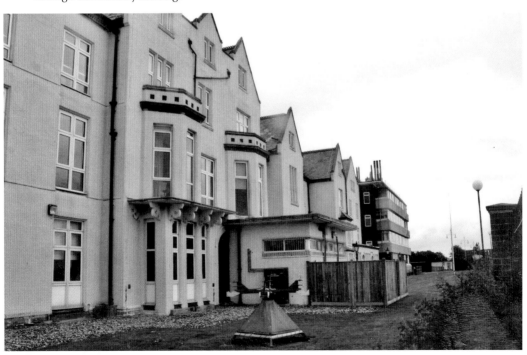

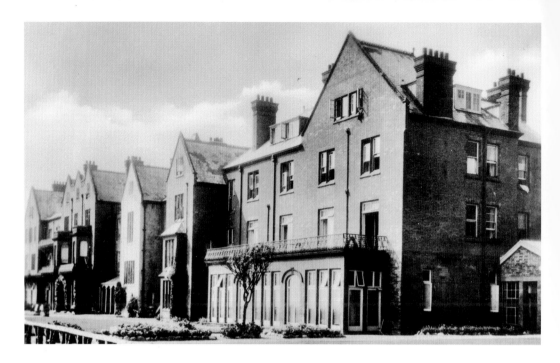

Promenade View of Grand Hotel

The hotel was taken over by the services during the Second World War and was eventually bought by the Ministry of Agriculture, Fisheries and Food in the 1950s. The Palais de Danse outlived the hotel, in 1953 becoming Watling's Lowestoft Palais with a roller-skating rink. When it closed in the early 1960s, it was absorbed into the MAAF premises. On 25 November 1999, Eliot Morley MP opened a new visitor trail and lookout around the cliff-top edge of what is now the CEFAS (Centre for Environment, Fisheries and Aquaculture Science) laboratories.

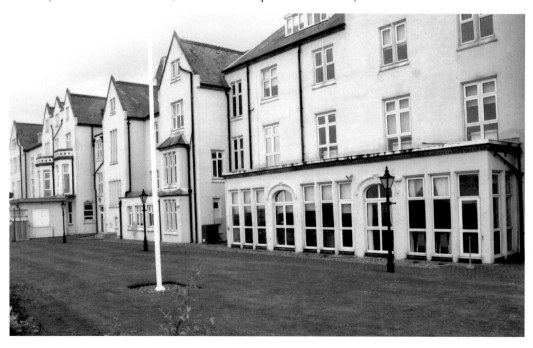

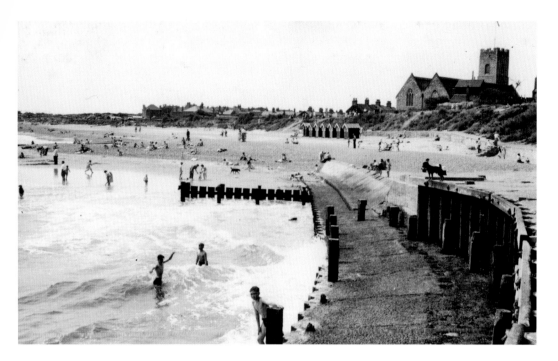

Pakefield (I)

A name synonymous with coastal erosion, this small village, a part of Lowestoft since 1934, still retains its original character. It has been estimated that some 150 acres were lost to erosion between 1822 and 1942. The Church of All Saints and St Margaret was once well inland, but the sea got so close that much of the churchyard was lost; bones were later found on the beach. On 21 April 1941, a German incendiary bomb set the thatched roof alight and caused substantial damage. The church was rebuilt after the war and rededicated in January 1950.

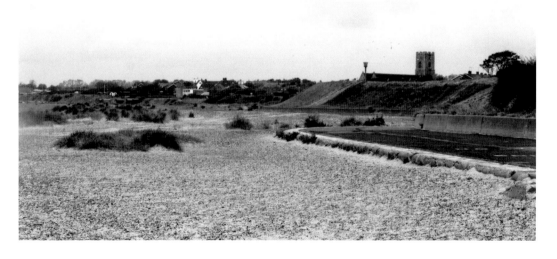

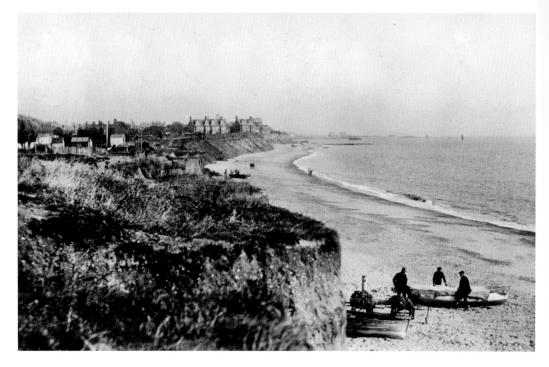

Pakefield (II)

The relentless sea nibbled away at the foot of Pakefield's soft cliffs, and sometimes without warning the cliff would collapse, taking a garden or sometimes a building with it. Lowestoft had constructed sea defences towards the end of the nineteenth century, but they ceased to be built in 1902, at the parish boundary near Pakefield Street. Over the years more than a hundred dwellings were lost, some of them substantial three-storey houses built at the turn of the twentieth century.

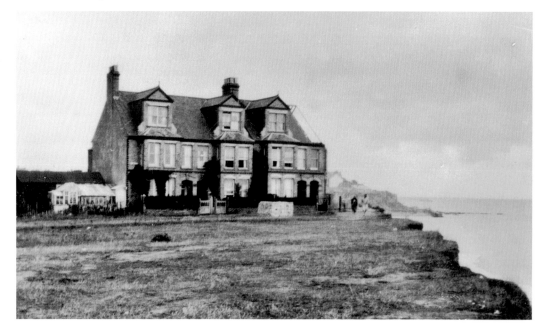

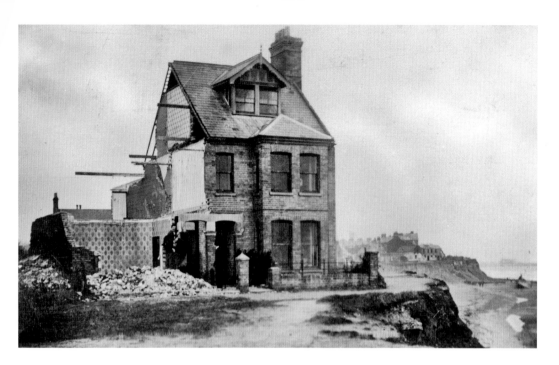

Pakefield (III)

Between the wars there was serious erosion and dramatic photographs show houses on Cliff Road and Beach Street being lost to the sea. Most of the wooden sea defences proved unsuccessful. After Pakefield's incorporation with Lowestoft, work began on the Jubilee Wall. This was interrupted by the war, but began again in 1942. Since then, the situation at Pakefield seems to have stabilised. The Jolly Sailors, which in the 1930s looked like it would be lost, survived to trade today.

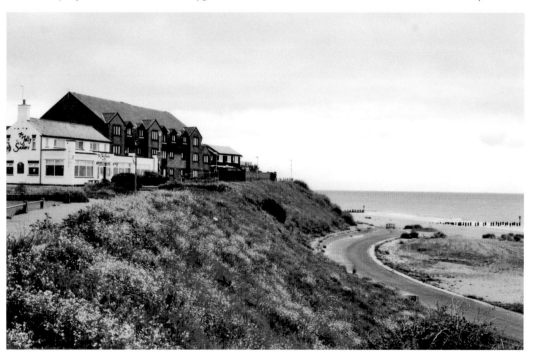

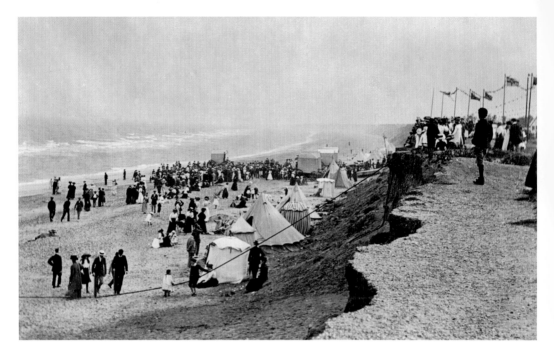

Pakefield (IV)

What is noticeable today is the depth of the shingle and sand bank and the marram grass and other vegetation on the cliffs and the beach. Such a calm and picturesque view belies the true history of seafaring in what are dangerous waters offshore.

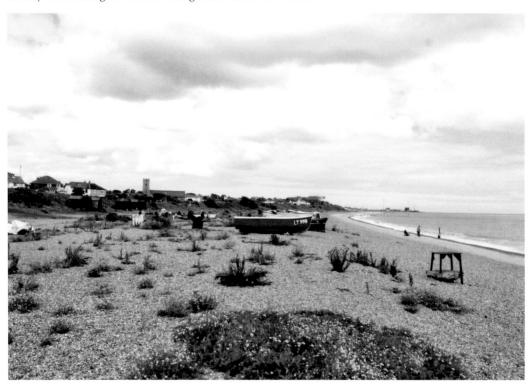

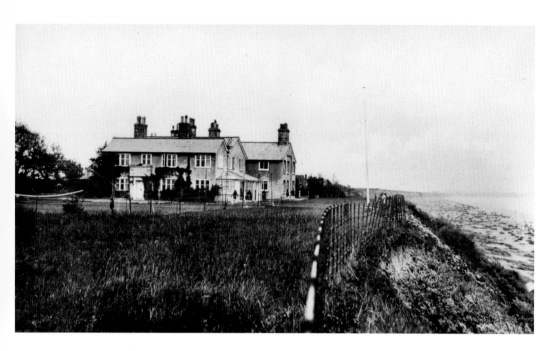

Kessingland Grange

Sir Henry Rider Haggard (1856–1925) bought the Cliff Grange property at Kessingland in 1900, possibly as a result of the success of *King Solomon's Mines*, which he had written in 1885 as the result of a five-shilling wager with his brother to write a story as good as *Treasure Island*. His great friend Rudyard Kipling was a frequent visitor. It was from the Grange that his daughter Lilias reported seeing a sea serpent in July 1912: 'a thin, dark line with a blob at one end, shooting through the water at such a terrific speed ... I suppose it was about 60 feet long.'

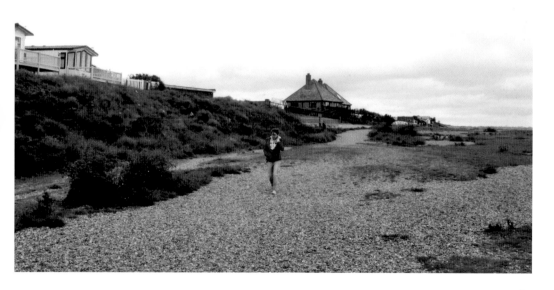

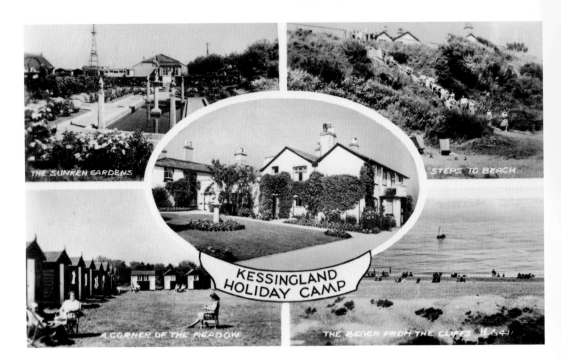

The Sunken Gardens | Steps to Beach | Kessingland Holiday Camp | A corner of the meadow | The beach from the cliffs

Kessingland

Rider Haggard renamed the house Kessingland Grange. In 1928 the Grange and its grounds were sold to a Mr Catchpole for the establishment of a holiday camp. The holiday camp developed with typical wooden chalets. In this postcard from the late 1940s, 'Pam' was 'having a lovely holiday. I can see the sea from my bedroom window, but as it is not very warm I have not been in yet.' Today the camp, covering some 65 acres, is run by Hoseasons, with caravan accommodation, entertainment and facilities for the family.

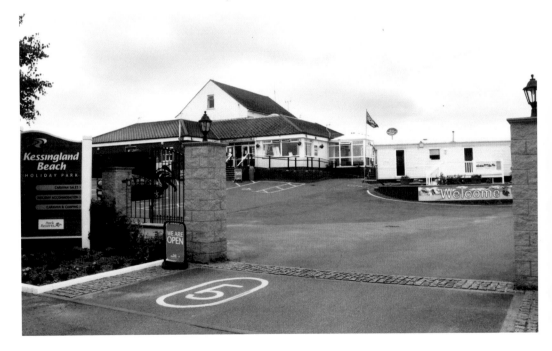

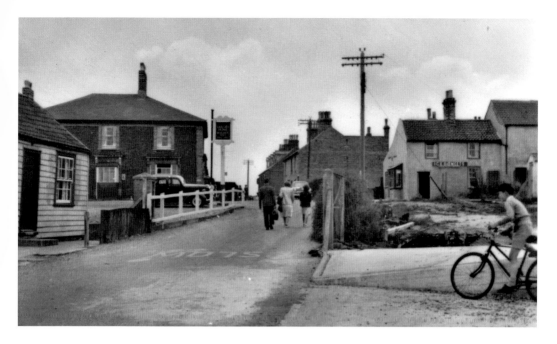

Beach Road, Kessingland

The Sailors Home public house and restaurant is on Church Road. The view has not changed much in the fifty years or so between the photographs. The Sailors Home looks out towards the beach and the sea and the Suffolk Coastal Path passes by the photographer's position. This is a fascinating area, rich in history and wildlife.

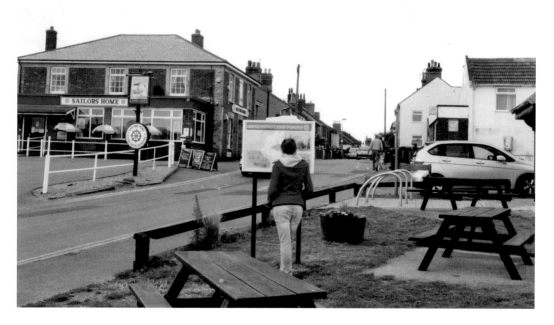

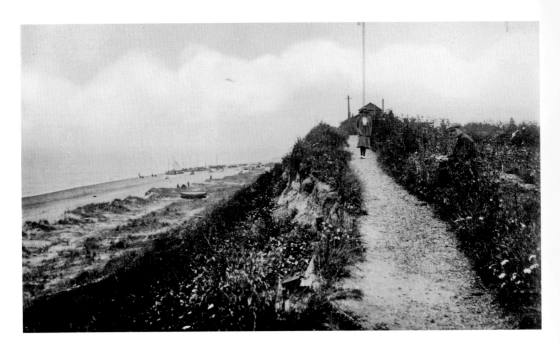

Kessingland Cliffs and Beach

The Suffolk Coast Path runs 50 miles between Lowestoft and Felixstowe. While Rider Haggard was at the Grange he sloped the cliff near his house and experimented with growing marram grass on it and had some success in stabilising and increasing the height of the cliff. Today the sea appears some distance from the sloping grassy cliffs and there are vast stretches of sand and shingle with tuffs of strong grass and other plants.

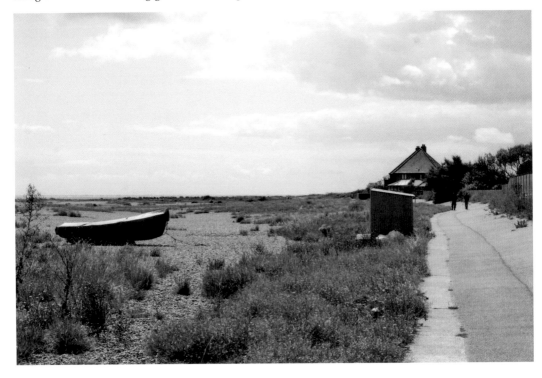

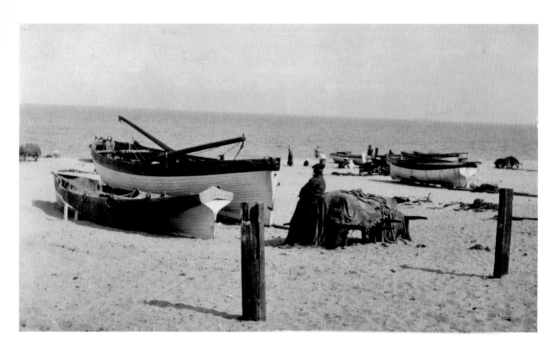

Kessingland Beach

Written in August 1921 to a neighbour in Camberwell, South London: 'Am much better now thanks to this beautiful air and delightful rest. There is absolutely nothing to do but rest.' Obviously he hadn't seen Lilias Rider Haggard's sea serpent and wasn't intent on going very far. Had he travelled a few miles north along the A12, he would have encountered a much livelier place at what had been known as Mutford Bridge.

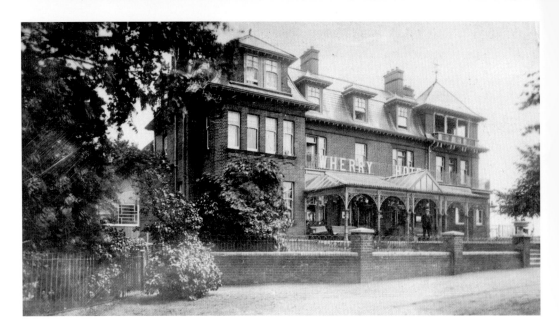

Wherry Hotel, Oulton Broad

It was George Mason, owner of the Wherry Inn at Mutford Lock, who in 1897 built a new hotel on the site of his inn to cater for the growing popularity of Oulton Broad. The railways had opened up the Broads area to visitors. At first, trading wherries were temporarily converted for the summer season and hired out to parties with a skipper and a cook/steward. Today the Wherry Hotel, which has changed very little since the Edwardian photograph was taken, offers thirty en-suite bedrooms, some with stunning views along Oulton Broad.

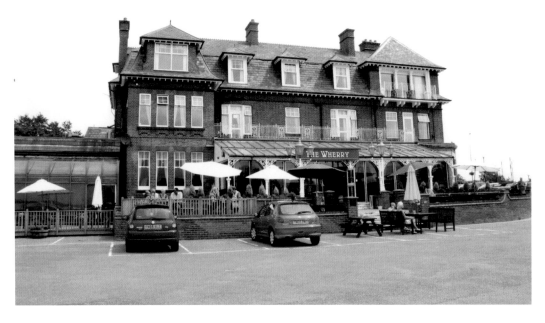

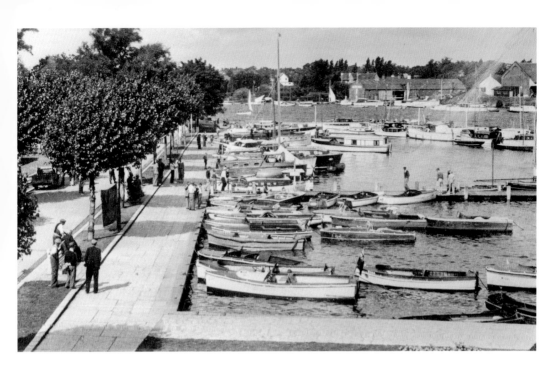

Yacht Station

The station is instantly recognisable, although many of the boats today look far more expensive and luxurious than in the earlier photograph. Oulton Broad is the southern gateway to the Broads National Park. It is a centre for boat trips, boat holidays, fishing, sailing, power-boat racing or just admiring all the activity.

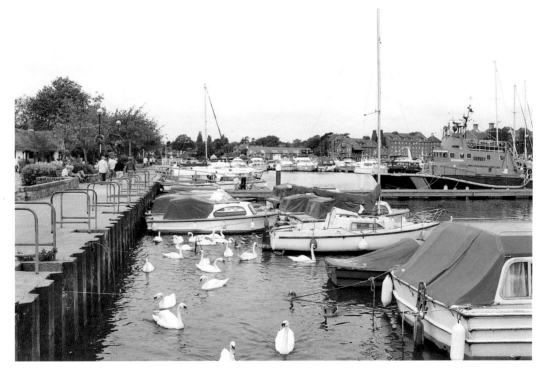

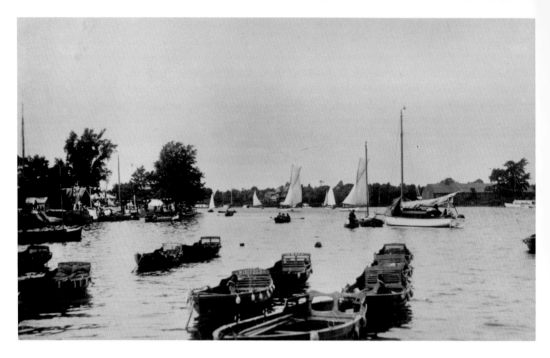

Oulton Broad (I)

Written in 1925 to Leicester: 'We have had a lovely holiday, plenty of boating and bathing. Have been to Oulton Broads quite a lot and had a sailing boat out one day on our own without an attendant. It was very thrilling at times!! So of course it suited the boys!'

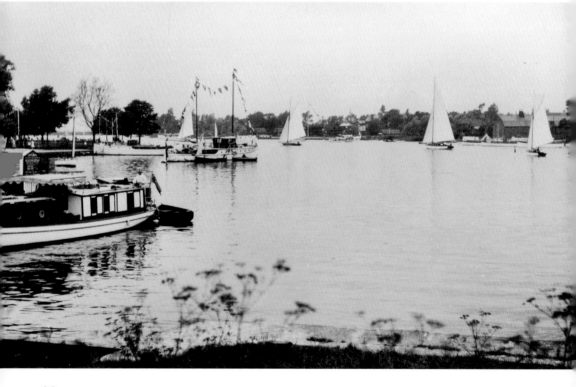

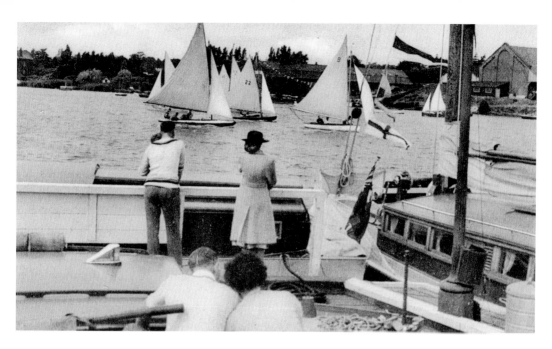

Oulton Broad (II)

It was a Sunday in June 2011, and I was strolling along the quayside at Oulton Broad. It was bright and sunny and there was a special event dedicated to the rescue services. People were sitting enjoying the water and looking at the various vehicles on show. There was a commentary running on the sailing races and the views were almost timeless. The *Waveney Princess* returned to her mooring place as I was photographing the scene.

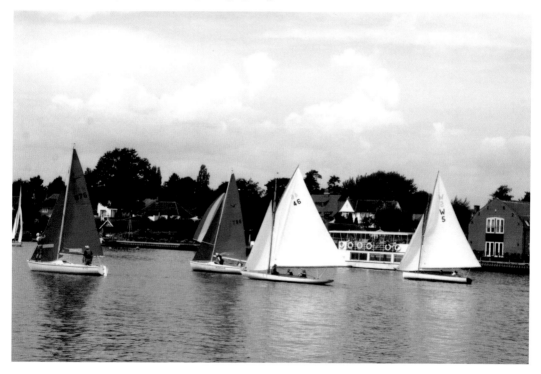

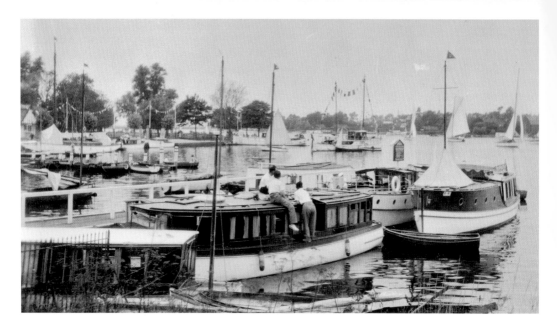

Oulton Broad (III)

There is a real 1930s feel to this photograph, with its mixture of houseboats and yachts reminding me of Arthur Ransome's books. The Broads were probably the result of medieval peat digging. Peat is partially decayed vegetation and the earliest stage of the formation of coal. It was dug in blocks, dried out and used for fuel.

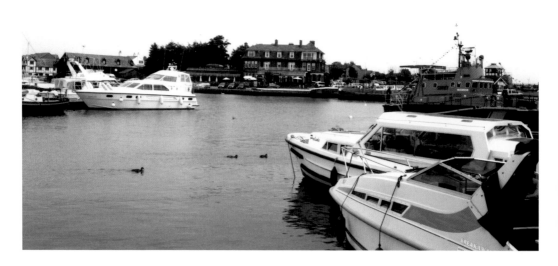

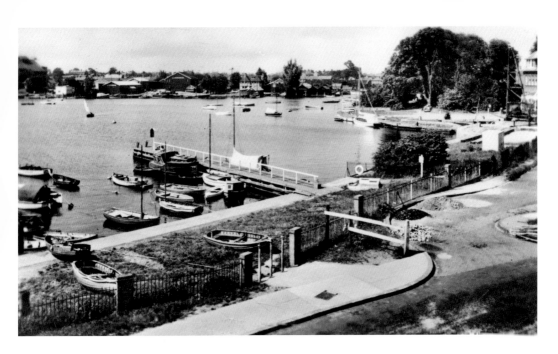

Oulton Broad (IV)

This photograph is from *c.* 1950; everything is so much smaller and quieter than today. The small wooden rowing boats and yachts have been exchanged for expensive-looking watercraft made from fibreglass and plastic. Essentially, though, the scene hasn't changed.

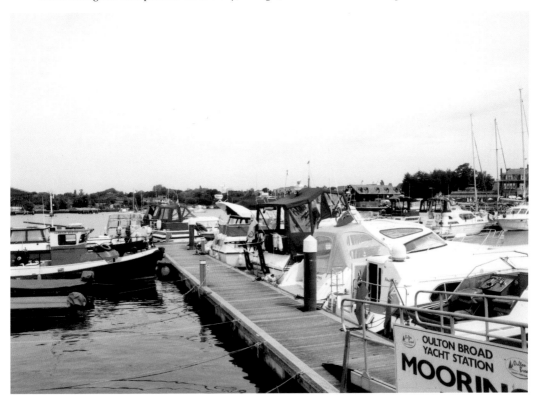

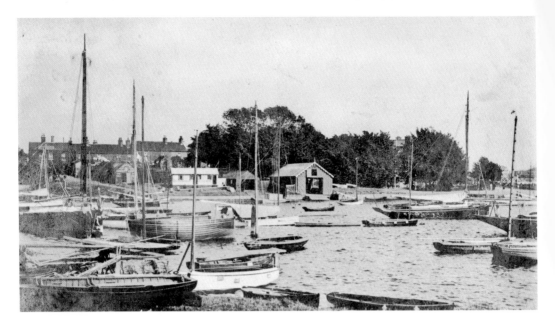

Oulton Broad (V)

A really early photograph, posted in August 1906 by 'GH', who was enjoying a holiday: 'We had such a ripping time here yesterday, went in a rowing boat with our minister, he is such a nice man ...' Small boatsheds and yards line the distant bank. Illustrating how busy Oulton Broad has become in recent years, in 2001 a new XP-class lifeboat began service here. Designed to operate in very shallow water, it has been so successful that now there is also a new D-class lifeboat donated by Charles Ryall in memory of his wife, Jean.

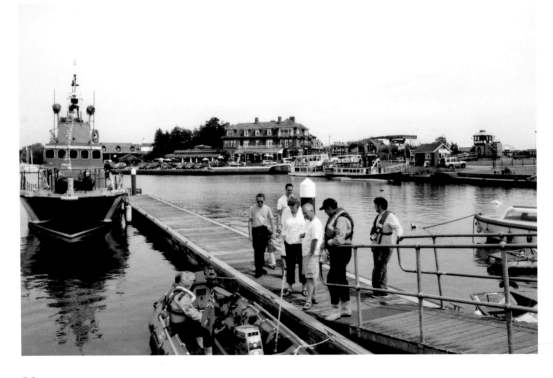

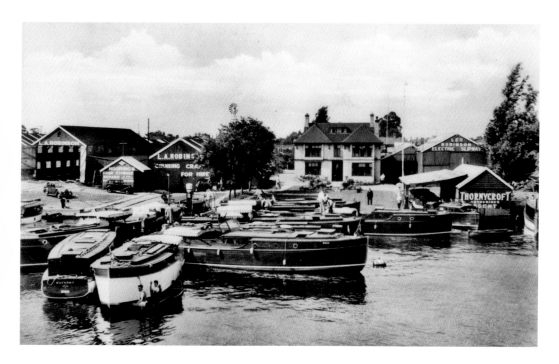

Broadside Yacht Station

Leo Robinson was one of the big names in boat building and boat hire on Oulton Broad, and by the 1930s he had built up a hire fleet of more than fifty craft. The firm went out of business in the early 1960s. Much of the area has now been cleared for the building of new apartments that will join the other luxury apartments that have been converted from old industrial buildings, principally the maltings of Swonnell & Son, which were built in 1900–02, expanded in the 1920s with two more maltings, and closed in 1968.

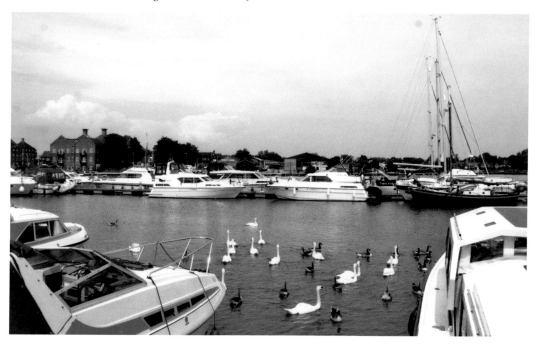

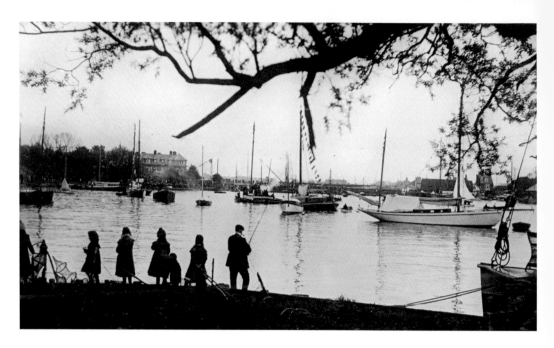

Oulton Broad (VI)

Over a hundred years separates these two photographs. From 1909 to 2011, the simple pleasure and challenge of fishing has continued to delight the visitor. An exception was the Norfolk-born writer and traveller George Borrow (1803–81), who lived for many years at Oulton Broad. He was once a keen angler, but it is said that in later life – having been challenged by the old Quaker Joseph John Gurney of Earlham Hall – he considered fishing 'cruel'.

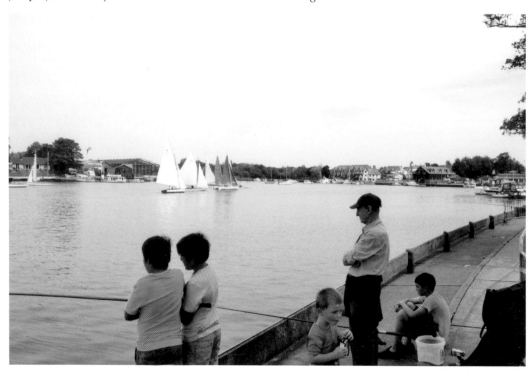

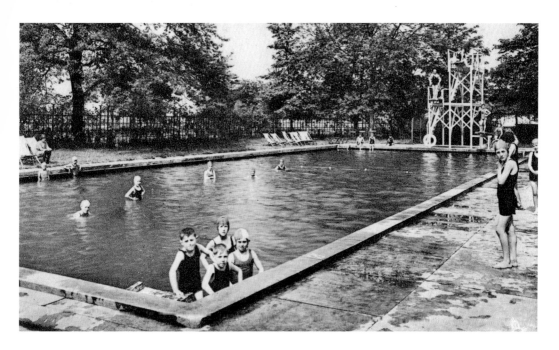

Swimming Pool, Oulton Broad

The pool is in Nicholas Everitt Park, which runs all along one side of Oulton Broad and provides a wonderful recreation ground with gardens, tennis courts, play areas, a bowling green, a bandstand and 'Pets' Corner'. The Park has just been awarded Green Flag status. The future of the swimming pool looks less assured. Nicholas Everitt lived at Broad House – now a museum – and after his death in 1928 his friend Howard Hollingsworth bought the estate and gave it to the town to be named after him.

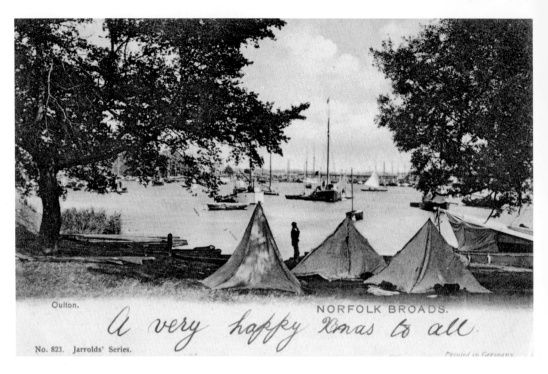

Oulton.

NORFOLK BROADS.

A very happy Xmas to all

No. 823. Jarrolds' Series.

Printed in Germany

Oulton Broad (VII)

From 1903 to 2011 nothing has really changed. We love the water and where better to sit and relax and reaffirm our faith in each other and the beauty all around us than Oulton Broad? We may travel the world and see its wonders and then return to what is near us and find contentment.

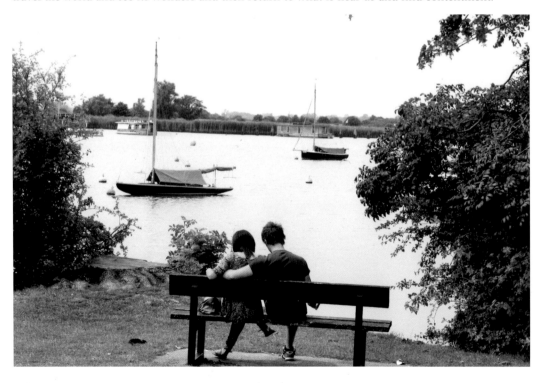